HOW TO START

PHOTOGRAPHY

BUSINESS

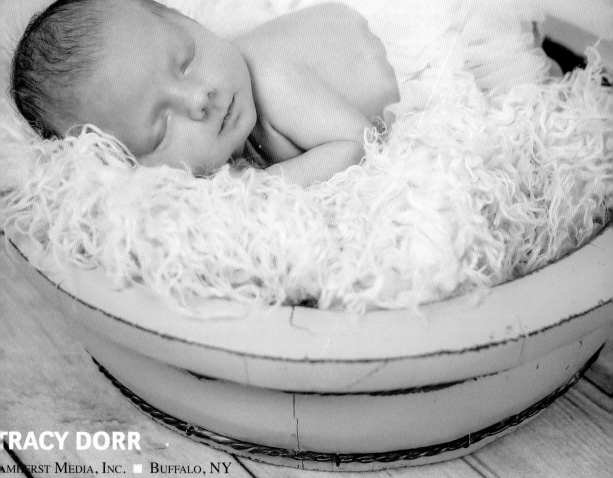

TRACY DORR

AMHERST MEDIA, INC. ■ BUFFALO, NY

DEDICATION

To my Annaleigh.

Published by:
Amherst Media, Inc.
PO BOX 538
Buffalo, NY 14213
www.AmherstMedia.com

Publisher: Craig Alesse
Senior Editor/Production Manager: Michelle Perkins
Editors: Barbara A. Lynch-Johnt, Beth Alesse
Acquisitions Editor: Harvey Goldstein
Associate Publisher: Kate Neaverth
Editorial Assistance from: Carey A. Miller, Roy Bakos, Jen Sexton, Rebecca Rudell
Business Manager: Adam Richards

ISBN-13: 978-1-68203-128-5
Library of Congress Control Number: 2016941018
Printed in the United States of America
10 9 8 7 6 5 4 3 2 1

CONTENTS

About the Author 5

1. Who Do You Want to Be? 7
2. Identify Your Specialty 11
3. Will This Make a Profit? 13
4. Being Realistic 15
5. Getting Experience 16
6. Setting Goals 22
7. Achieving Your Goals 24
8. Creating a Budget 27
9. Large Businesses 30
10. Small Businesses 34
11. Choosing a Studio Location 36
12. On-Location Portraiture 40
13. Shooting Studio Portraits 42

14. Travel . 48
15. Employees 52
16. The Right Equipment 56
17. Equipment Failure 60
18. How to Handle Problems 62
19. First Impressions 71
20. Contracts 72
21. Legal Issues 76
22. Postproduction & Workflow 79
23. Timeliness 82
24. Building a Portfolio 84
25. Your Signature Style 88
26. Taxes . 92
27. Business Classifications 95
28. Networking 97

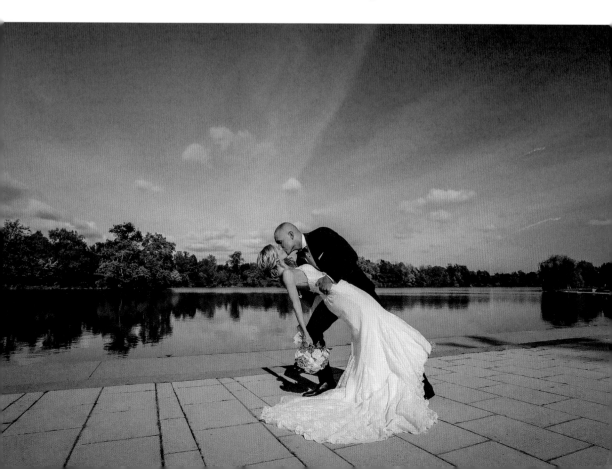

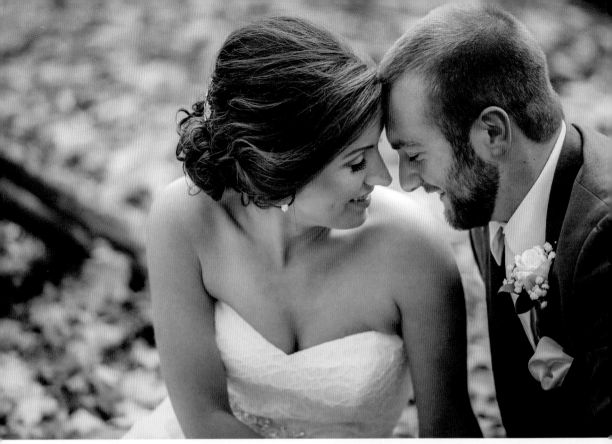

29. Advertising 100
30. Marketing 102
31. Creating Lifetime Clients 105
32. Word-of-Mouth Referrals 108
33. Social Media Networking 110
34. Continued Growth 114
35. A Changing Industry 118

Conclusion . 124
Index . 126

ABOUT THE AUTHOR

Tracy Dorr is a photographer, writer, and the co-owner of Capture Your Heart Portrait Studio. She is the author of four books—*Advanced Wedding Photojournalism: Professional Techniques for Digital Photographers; Engagement Portraiture: Master Techniques for Digital Photographers; Set the Scene: Props for Portrait Photography;* and *The Beautiful Wedding,* all from Amherst Media.

Tracy holds Bachelor's degrees in English and Photography from the State University of New York at Buffalo (UB) and has been shooting professionally since 2003. She won three Awards of Excellence from the Wedding and Portrait Photographers International competition (WPPI) and was a Master Class teacher at the WPPI convention in Las Vegas, in the MGM Grand.

Her work has been published in numerous local wedding publications and is on display in a number of local businesses. Her images have been published in seven books in Amherst Media's *500 Poses* series by Michelle Perkins, on the subjects of brides, men, couples, groups, full-length portraits, children, and infants and toddlers. She also contributed to Michelle Perkins' book *How to Photograph Weddings;* the work highlights her aesthetic and point of view in an interview about her craft.

Tracy lives in Williamsville, NY, with her husband Bill and daughter, Annaleigh.

To see more of Tracy's work, visit her websites at www.tracydorrphotography.com and www.captureyourheartstudio.com.

WHO DO YOU WANT TO BE?

YOUR PERSONAL ROAD MAP

Do you dream of being your own boss? Do you imagine spending your days working passionately and creatively?

There are many satisfying and rewarding aspects of being a photographer. If you fantasize about starting your own photography business but find yourself perplexed and overwhelmed by the hurdles inherent in getting started, this book can help. It will define the basics of the business and, more importantly, establish a dialogue of relevant issues that you will need to understand in order to form your own opinions about how to run your business. Those issues will inform most of the choices you'll have to make.

Sometimes it seems as if there are so many business considerations that it can be hard to know what the best decision is. The truth is, every photographer will make their own choices based on personal opinion, guided by experience. When you don't have experience, look to those who have gone before you and ask how they feel. Their opinions and history will inform

Previous page and below—Images by Tracy Dorr.

your decision-making process. This will be a powerful tool as you venture out.

In this book, you will learn about the myriad issues facing new business owners. In the majority of sections, you will find sidebars in which the pros present their (sometimes opposing) opinions on various matters. These insights will provide valuable guidance. In general, there are no hard-and-fast answers to business startup questions. In most matters, there is no clear-cut right or wrong approach (legal and tax matters are an exception). As you read through the sidebars, you can adopt the strategies that make the most sense to you and seem to best suit your goals. Let the pros' experience and anecdotes inspire you.

Turning a hobby that you love into a lucrative profession is filled with challenges. Begin by asking yourself if you have a clear idea of what type of photographer you are at this point in your career, and who you hope to become. Personal growth is crucial in this business. At the end of your journey, who do you want to be? How do you envision your future in five years? Ten?

Over time, you will define your own path, and this book can help you start off on the right foot.

YOUR NICHE

There are many different types of photography businesses. There's no set formula as to the size of business or style of photography you need to choose in order to achieve success. Individuals working alone enjoy full control over all aspects of the business and have the ability to engage in intimate, one-on-one transactions. They may specialize in portraiture alone. Some studios consist of a husband-and-wife team or a partnership of two like-minded individuals. A larger studio may employ several photographers and have all of them out working at the same time so that they are able to take more jobs and create simultaneous income. A business of that size could easily handle several weddings in a day and can generate double or triple the number of word-of-mouth referrals.

Will your niche turn out to be portraits and/or weddings? Or will you take a more targeted approach and focus on a subgenre like newborn or pet portraiture, or a specific style of fine art? Will you maintain a physical studio or work exclusively on location?

If you don't have a fixed idea yet of what type of business you want to run, examine your body of work and try to hone in on what makes you special. Elaborate on your strengths and focus on growth—both personal and economic.

Dare to create the business of your dreams.

Previous page—Image by Tracy Dorr.

IDENTIFY YOUR SPECIALTY

TAKE STOCK

If you have a solid body of work, take some time to review it. Try sorting your photos into various groupings based on subject, tone, or style. Next, review each collection to see where your strengths lie. If your forte appears to be photojournalism, babies, or architecture and you really enjoy shooting those subjects, you might consider making it your specialty—the basis of your business.

A BODY OF WORK

If you are a new photographer and do not yet have a portfolio, your first step in charting the course for business success will be to produce a body of work. Identify your favorite images, and then ask yourself why those images speak to you. If you find a common thread in your work, what is it? Why do you gravitate toward it? What excites you?

Whether it is a subject matter or a post-production technique that you favor, you can capitalize on your passion and develop that strength to stand out in the market-place. Use your unique vision to create a niche that you can call your own—one that doesn't rely on copying the work of others or simply doing what you are told. When you are starting out, you must follow the instructions of an experienced mentor. Once you are thoroughly trained, you will

be able to make your own aesthetic decisions. Starting your own business is your chance to create a specialized product that no one else offers.

Previous page and below—Images by Tracy Dorr.

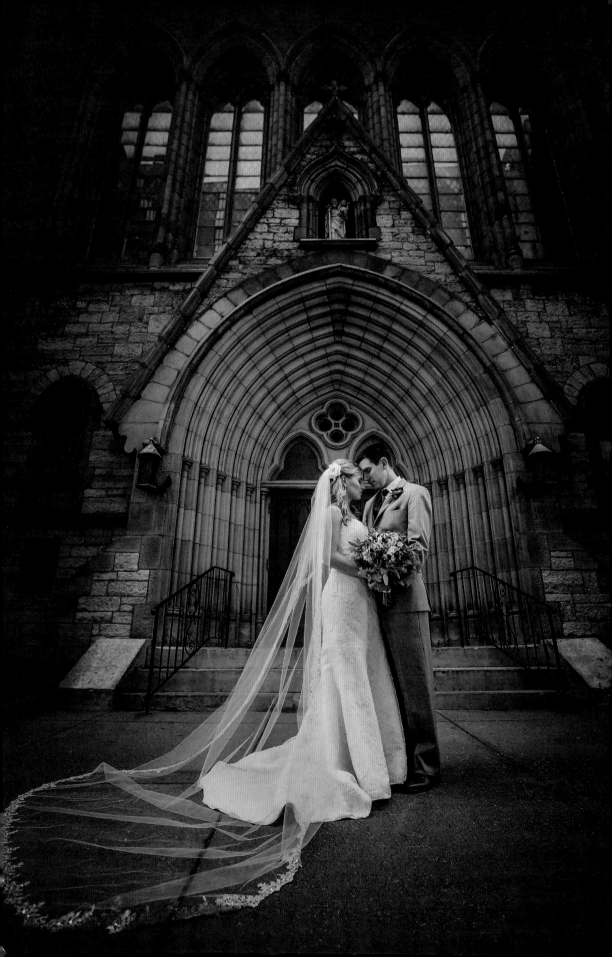

WILL THIS MAKE A PROFIT?

KNOW WHERE YOU STAND

A business can only subsist long-term if it is profitable. To thrive, it is important that your product is unique enough to stand up to the competition. That's why it is imperative that you have a specialty that you can be identified by. Naming your business to reflect your niche can help you gain recognition. For example, names like Cleveland Pet Photography or Bumps and Babies Photography will attract the attention of clients in need of such pictures. Your product is further shaped by your personality, reputation, and business practices.

Take a look at the market in your area. Note the existing photography businesses and determine what they are offering. You'll also want to determine how many businesses specialize in the niche you want to pursue. If there are fifty newborn and baby photographers in your area, will there be enough room in the market for you? If you intend to break into the wedding market, how many other studios will you be in competition with? What is the average number or weddings per year in your city? (A bridal association may be a good resource for determining this.) Is there enough

Previous page and above—Images by Tracy Dorr.

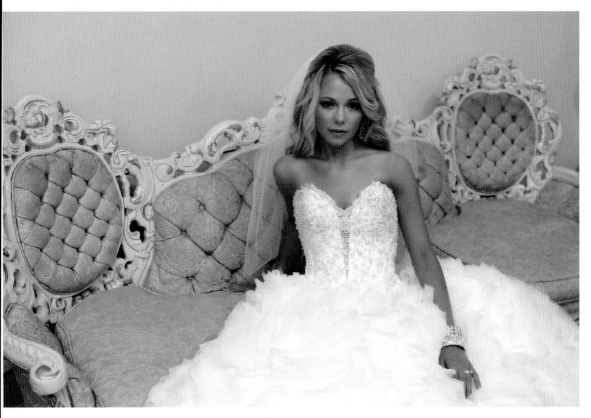

Adjusting for Profit

business to go around? If there are hundreds of wedding studios in your vicinity, you may need to adopt a dual specialty or choose a different one altogether in order to make enough money. Your first choice may not be the perfect fit after all.

GAUGE THE DEMAND

You will also want to determine how much demand there is for your service or specialty. If your style is highly specific, you won't find a wide customer base. That's just fine,

so long as the rate you charge and number of customers you draw net the profit you need. Your goal should always be to move forward and grow. You will need to amass enough profit to invest in equipment, props, and advertising. Most of all, you will need sufficient income in order to continue to practice your craft, expand your skills, and fuel your passion.

Image by Joseph Priore.

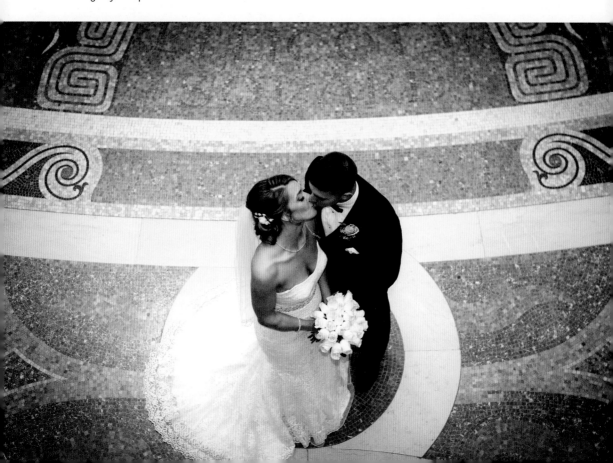

BEING REALISTIC

CONSIDERATIONS

It is important to be realistic about how quickly you can grow your business and where you should start. Here are some key things to consider:

- Is there enough room in the market for me to launch my business?
- How much am I willing to put into start-up costs?
- How much can I reasonably charge my customers when starting out, without undercutting the local industry?
- What is the average number of clients per year I hope to service? How many customers can I anticipate in my first year?

THE EARLY STAGES

Embark on this adventure with the understanding that a business faces an uphill battle during its first few years. Until you build a strong client base, you might be hurting for work—and that's okay. Every seasoned photographer can remember being an eager apprentice, hungry for any type of work. That's where your passion stems from, and it blossoms into a wonderful gift. In fact, I believe it is important to remind yourself of this from time to time because it creates a renewed passion for the craft, which may wear down over the years.

Start at a comfortable level, even if it's small. Though you may dream of owning a building someday, you may need to start at home or rent a studio until you can afford to buy your own place. Carefully weigh the pros and cons of starting out big. Be savvy when it comes to investing. It will take time to get the word out and grow your business, so exercise some caution while you fuel your excitement for your new job.

Image by Tracy Dorr.

GETTING EXPERIENCE

Experience is fundamental in every genre of photography. No matter the specialty you pursue, it is imperative that you have logged enough hours to build a solid foundation. You must be seasoned enough to handle any problem that arises, whether you're engaging in a commercial, portrait, or wedding shoot.

If you're offered a job that's too big or otherwise over your head, hire or partner with a photographer who has done it before. That way, you can learn and there are two of you to handle a larger volume of work. If you want to acquire more experience, you can offer special introductory rates or apprentice with someone who does a lot of that type of work.

ARCHITECTURE, REAL ESTATE, AND COMMERCIAL WORK

Networking is key for architecture, real estate, and commercial photographers. These are generally not jobs that you advertise for. They often come from word-of-mouth referrals from people who have worked with you before.

Images by Joseph Priore.

Still, it is a great idea to have marketing materials on hand, have a great portfolio prepared, give out your business cards, and be sociable with agents and business owners. Also, make sure to do your research. Turn to books and tutorials in order to learn the fundamentals of this type of photography.

You might consider offering a group rate to entice bosses to upgrade to a company-wide shoot while they have you in the building. Focus on shooting during business hours to make getting the job done as easy as possible for everyone.

Keep your rates fair and reasonable for long-time customers.

A Change of Pace

"I like commercial jobs for a number of reasons. You're dealing with a bigger company that's willing to spend for a bigger job. Usually it's work conducted during business hours, which is nice—and it's refreshing to work on something other than weddings and portraits. It provides a change of pace."

—Joseph Priore, www.priorephotography.com

PORTRAITS

There are several ways to learn portrait photography or enhance your existing portrait skills. If you are just starting out, your smartest move is to find someone to apprentice with. This mentor can help you learn all of the basics. To achieve success as a portrait photographer, it is important to ensure good photographer–client interactions, and working with an established pro can help you learn how to build rapport with clients. It is something you have to learn on the job.

Another way to gain experience is to advertise some portrait specials that will lead to experience in the areas you want to master. By offering free shoots or free sittings, you and your client both win. You get fresh portfolio-building images, and the client gets some discounted or free images. This allows you to tackle new situations, try out new concepts, and make contacts with prospective lifetime clients.

WEDDINGS

Experience is of the utmost importance when starting a wedding photography business. Therefore, it is wise to train with a seasoned pro. Weddings are high-stress, high-income days that you cannot repeat. It is critical that both you and your staff are fully vetted in the art of wedding photography. You must be able to deliver the product you pitched without any major hiccups, or you may face a very angry set of newlyweds and their families and, in the worst-case scenario, refunds may be in order and/ or legal action may taken against you. You have an awful lot of people to please simultaneously on the wedding day, and the last thing you want to do is ruin their memory of the event.

Because weddings are high-stress occasions for all of the parties involved, your customer relations skills must be strong. You will need to be at the top of your game and act in a professional manner to book the date and get through the wedding day. After twelve to fourteen hours, fatigue can eat away at your patience, so it is important to instinctively know how to handle yourself.

To be successful as a wedding photographer, you must gracefully and efficiently

Left and following page—Images by Tracy Dorr.

react to potential problems and/or very real, sudden mishaps. This is a skill learned only through experience. Your ability to not let stress impact your performance will save you. You often have an opportunity to be an asset to a bride in need. Your experience can help her navigate her day when things aren't going according to plan—and this is something she is certain to remember.

ARE YOU READY?

Start booking your own weddings only when you are truly ready, and make sure that anyone working with you is equally qualified. If the customer is paying you for two full-fledged photographers, don't bring a trainee who is out on their first job; bring an experienced pro. Make sure that the customer gets the product they deserve. If you want to train someone, add them as a third shooter or train them on another occasion. If you sell only one-photographer packag-

es, then you will have ample opportunities to take an assistant along with you as an apprentice when the need arises.

POINTS OF VIEW

"I want to keep good customers coming back, so I offer 'preferred customer' rates for people who have given me a lot of business. It's a thank you for returning, and it lets them know I am loyal to them, too. I think that it leads to good word-of-mouth referrals for other corporate jobs."

—*Joseph Priore, www.priorephotography.com*

"It is important to have a general idea of what other professional photographers are charging for certain projects. If all of your prices are extremely low, some potential clients will overlook you, as a low price can often mean low quality."

—*Drew Zinck, www.drewzinckphotography.com*

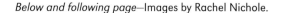

Below and following page—Images by Rachel Nichole.

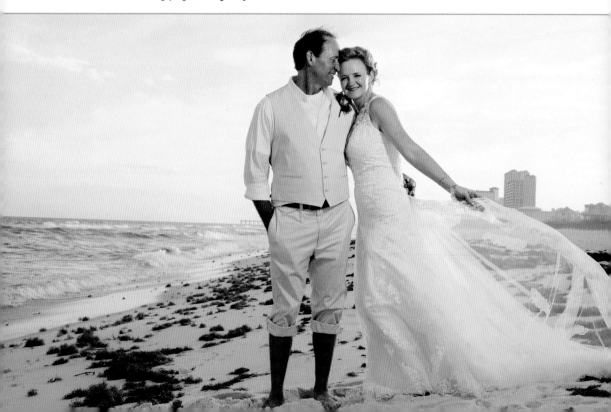

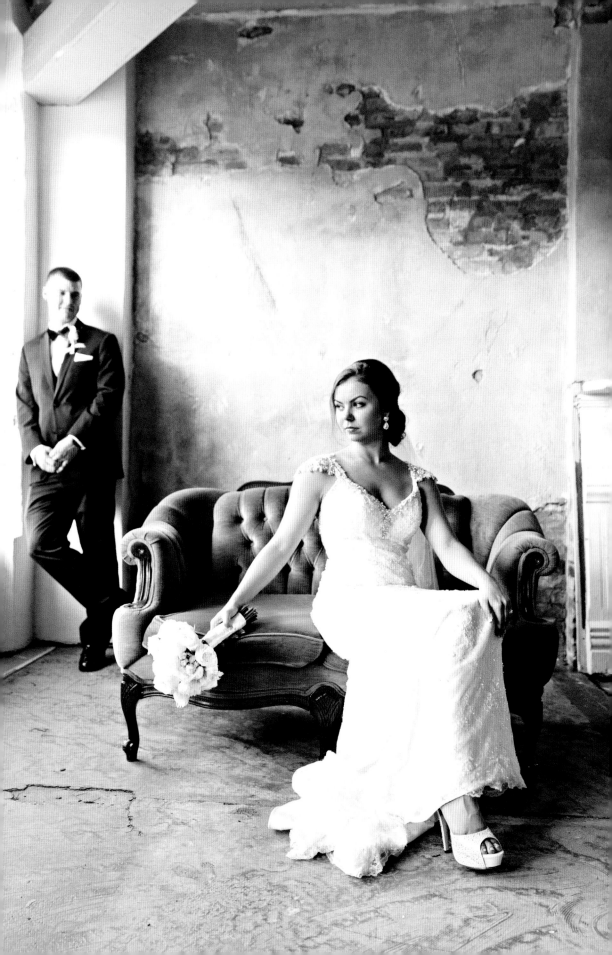

SETTING GOALS

SMALL STEPS TO BIG PAYOFFS

A fledgling business will benefit from a well-developed plan. Utilize a business model for your first year(s), make a list of goals for yourself, and set a timeline for when you hope to achieve them. Having a written strategy that you can refer to on a daily basis can have a positive effect on you as you make your way through the ups and downs of your turbulent first years. A written plan will also help you stay accountable and keep you on track to reach your goals.

To start, try setting goals on three levels: First, aim for small objectives with daily or weekly deadlines. These should be simple enough to be achieved with relative ease. Next, list long-term goals to be achieved in a matter of months or one to two years. Finally, add the dream goals that you would like to achieve several years down the line. Your dream list will be filled with things that exceed your expectations.

MEETING AND ADAPTING TO CHALLENGES

New business owners are sure to encounter some unexpected events and obstacles, so you must be mentally prepared to roll with the changes and adapt. Keep your goals

Image by Tracy Dorr.

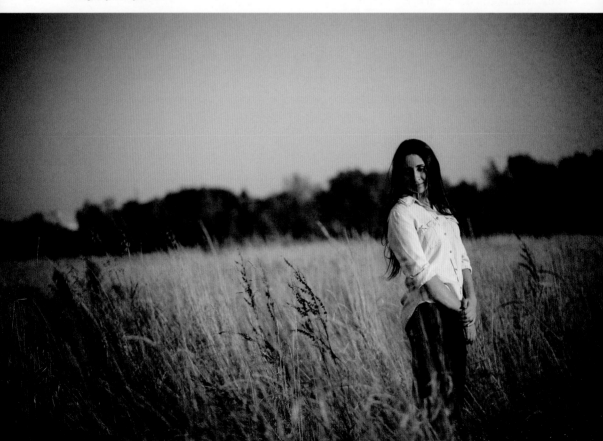

flexible. For instance, if you overestimated the demand for your particular skill, then you may need to embrace more than one type of photography. If you thought you would specialize solely in real estate photography but found that the interest was limited, you might need to incorporate commercial portraiture or product photography.

You may also need to adapt in order to take on more work. For example, if you find that there is a good demand for real estate jobs, you'll have a lot of work to keep you busy, but those clients may ask you to produce headshots or group shots for their office and brochures. When customers are satisfied, one job often leads to the next. At that point, you'll need to ask yourself, "How much work can I realistically accept if I am to offer the highest quality?" and "How much do I need to charge to pay the bills and turn a profit?" The platform for success is about achieving balance.

When setting goals, you'll also need to think about the costs of doing business and the fact that your projections might change:

- Ongoing cosmetic updates are required to keep the studio in peak condition, and they are often more expensive than you anticipate. Repairs and general maintenance costs vary widely.
- Marketing and advertising could end up doubling if you don't immediately see the client response you were hoping for.
- Bookings can fluctuate yearly in the portrait and wedding photography markets.
- Cancellations can quickly cut into your profit margin.

- You might attract more business than you anticipated. While this is a great problem to have, you'll need to determine how much work you can handle on your own before you need to turn down jobs or hire an associate photographer. For example, Aileen Treadwell projects how much business is coming at the end of the year with her Christmas rush, then limits the number of appointments she offers so that she doesn't get herself in over her head. By making sure she doesn't take on too much, she knows she can provide her customers with their images in a timely fashion and keep everyone happy.

Income Stability

"I try to offer one mini-session every one to three months in order to ensure a steady flow of income. Santa shoots are a huge part of my yearly profits, so I always plan for that income. I add that with my mini sessions and aim to book an additional one to five sessions per month, but no more than that so I keep true to my stated turnaround times."
—Aileen Treadwell, aileentreadwell.com, www.babydreambackdrops.com

Helpful Hint

The no-brainer goal: Make more money than the year before. You want to see continued growth year after year.

Be realistic in the beginning. Don't go into business planning to make $1,000,000,000.00 the first year.

ACHIEVING YOUR GOALS

STAY INSPIRED

Once your goals are written down, you have visual inspiration. Display your written plan someplace where you will see it daily for a constant reminder. Next, it's time to truly dedicate yourself to achieving your goals. Allocate the time needed and embrace a strong work ethic to pursue your goals and see them through.

If your goal is to make a living solely on photography—an ambitious and admirable goal—it is imperative that you achieve it, or you won't have enough funds to live day to day. However, even if it's a side business, you will want to build it up enough to keep generating interest and word-of-mouth referrals. Network with customers and bring in new people as often as possible. Aim to expand your client base every year.

EVALUATE YOUR PROGRESS

Always modify your initial goals as you progress. If you can't achieve what you projected, use the knowledge you've gained to adapt your goal. Use what you've done wrong to re-work everything and do more

Image by Neal Urban.

Image by Neal Urban.

right. If that doesn't work out, reassess. If you have a goal of paying off startup debt quickly, don't go crazy overspending on things until you have made progress repaying that debt. There's not just one way to achieve a goal; always consider multiple options and strategies. Make sure you stay apprised of all available options and continually adjust as you go.

The early years of a new business are confusing and challenging. Mistakes and mishaps are par for the course, but the lessons learned and your own gut feelings will help you to move toward success. Sometimes, it can be a big help to hear other people weigh in on the issues you are facing.

POINTS OF VIEW

"The trick is to find what works best for you, but if you go about it multiple ways, you will have more 'hats in the ring,' so to speak. For example, imagine that you are starting a new business and put in $40,000 for equipment and rent for studio space, etc. Now you have multiple options: you can pay off $10,000 a year for four years, take a loan for the entire amount and pay it back monthly, or pay the minimum for the first year while you're getting going and pay the rest in one huge chunk. The important thing is that your payback goal has a timeline. Don't let it get away from you."
—*Joseph Priore, www.priorephotography.com*

"Get educated in photography. Read. Learn. Be ready for all the questions that will be asked, and experience will follow. That's how you achieve your goals."
—*Frank Priore, www.priorephotography.com*

"My advice to new photographers is don't give up! Don't be afraid to try new things. Many people enter the photography industry thinking it's a fluff job. Without prior experience, many people don't realize how much work it is. It's easy to get discouraged in the beginning when you're putting in a great deal of time and money and getting little out of it. It's all part of gaining experience. I have gone through many growing pains over the years. I've tried things that haven't worked, and the things that did work are what made my business flourish."
—Dana Marie Goodemote
www.danamariephoto.com

"The most important thing to remember is to take it slow. If you decide to go full-time too soon, you will put a lot of pressure on your photography, and your skills might not be fully realized yet.

Set realistic goals. For your first year, try booking a handful of weddings—maybe five to eight. Shoot your heart out, put everything you've got into it, and show the work! For your second year, double the number of bookings. Continue this way until you can live on your photography salary."
—Neal Urban, www.nealurban.com

"Surround yourself with other photographers. Ask them questions, listen to their advice, and do not dismiss their guidance. I've learned so much by talking with photographers who've been in the industry longer than I have. Plus, they know lawyers, insurance agents, accountants, etc., who have experience dealing with the specific needs of photographers.

It's also important to be willing to grind. If you are serious about being successful in photography, you will need to put in a lot of effort. For the better part of four years, I did not take a vacation for more than a long weekend because I needed to work at my business. I was up late—2:00AM, 3:00AM, even 4:00AM—working on social media, my website, and putting together mail pieces more nights than I care to think about. On days when I was slow, I called people and went to offices to drop off my business cards. I would go to open houses just to meet agents."
—Drew Zinck, www.drewzinckphotograpy.com

CREATING A BUDGET

Creating a workable budget is one of the first things on the agenda for those who want to start a photography business. You'll need to have some idea of how much you'll spend so you keep yourself from going overboard. You'll also need to have a basic idea as to how much profit you can expect once your expenses are paid.

Gather information about your local market. You'll want to research where advertising dollars are best spent in your area. How much does each type of ad cost? What kind of traffic are you looking at for the

money spent? For example, bridal planners, local magazines, or newspaper ads all have different cost structures and reach different markets. Only you can determine which clientele you're looking for and how much you can afford to spend to target them. Bridal shows and art fairs are important to look into, as is any forum that lets you meet new people and share your talent.

In your first years, you won't be making what you expect down the line. Your income will likely be minimal. To project your future income, consult guides that list

Image by Tracy Dorr.

annual incomes or ask questions of your mentors. Also, when you are first starting out, you don't have a prior year's income to base your budget on, so the best thing to do is be conservative and find a comfortable place to start. "Each year, when you know what you made the previous year, you should reassess and change," advises Joseph Priore. "Your budget is dependent on your lifestyle. How much do you need to make? Weigh the pros and cons of each big expenditure. For example, how much do you pay your employees? How high is your rent? What will yield you more profit?"

A good way to gauge progress is to ask your clients how they heard about you. Utilize their feedback to see where your advertising dollars are really working and assess how people are finding you. For instance, if your business is 80 percent referrals, you know you can dial back the amount of money that is alloted for print ads. If people are bringing a coupon you've been running in the local paper, keep it up. If you feel like you're getting your money's worth, then you're probably heading in the right direction.

What's involved in creating a budget? Most businesses will need to plan for salaries for staff, equipment, rent, props, repairs, gas/car, utilities, office supplies, unexpected expenses or emergencies, advertising, marketing materials, printing, phone service, Internet/computer, travel, and continuing education. The remainder is your projected profit.

Previous page—Image by Rachel Nichole.

Budget Planning

"My advice is to really figure out how you want to start advertising. Be smart about deciding what to spend; make sure you've done a lot of research so that you're getting a return on your advertising investment. Start yourself a good budget and avoid creating a lot of overhead you can't afford. It's also a good idea to ask experienced photographers what has worked for them and consider whether it will work for you. I feel like you have to be willing to bust your butt to achieve your goals and stay on top of every little part of your business. I believe starting a business isn't a side project or part-time thing. From the moment you wake up, you're always moving forward to get where you want to be."

—Joseph Priore, www.priorephotography.com

A No-Goal Approach to Getting Started

When Drew Zinck was launching his real estate photography business, he found that what worked for him was not setting extremely specific goals, but getting to work quickly. For him, persistence paid off.

"My objective was to get as busy as I could. That meant cold calling, because that was my job. On days I was slow, I had to get my name out in front of people who I wanted as clients. People were not going to magically find out about me. The first year, I probably made over 1000 cold calls to agents."

LARGE BUSINESSES

GO BIG OR GO HOME?

If you decide to start big, you may need to book two hundred weddings and you might have a staff of ten to twenty. Running a studio that size typically means higher stress levels for the owner. (Think about two hundred weddings, multiplied by 1500 photos per wedding—that's 300,000 images a year you are responsible for providing at the highest quality!) Of course, a bigger studio has the potential for bigger returns. Decide how much of a risk you are comfortable taking. Keep in mind that the potential for mishaps increases as you add more employees and customers.

WORKING WITH OTHERS

Working side by side with someone else can have a profound and positive effect. Though it forces you to release some control and compromise from time to time, it yields a broader and more substantial vision for your business. You each bring different things to the table, and what your partner contributes will shape and redefine your future in ways you hadn't predicted. As you

Image by Tracy Dorr.

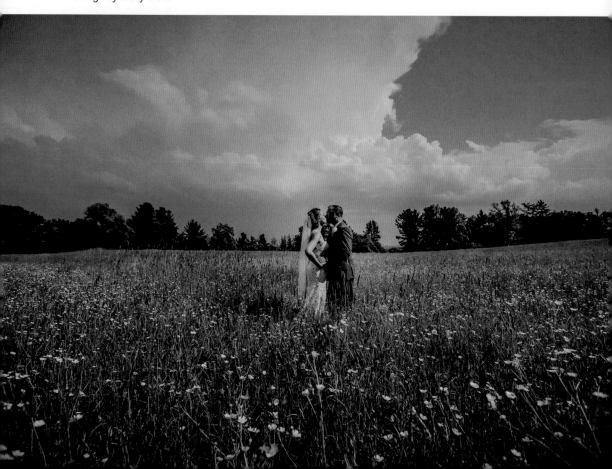

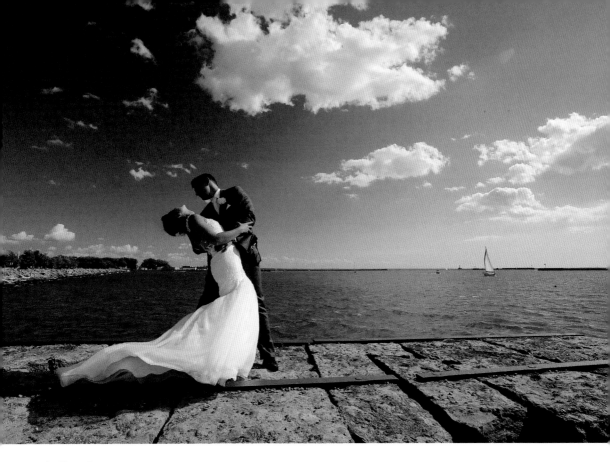

Image by Tracy Dorr.

merge your personal aesthetics, you gain strength and cohesion in your united vision. You often find yourself taking a direction you hadn't imagined pursuing until you met them. Then you'll find it's a perfect fit—the missing element you didn't know you were lacking.

You will need to have confidence in your supporting photographers; you will sell their work under your name, so their talent should match or surpass your own. It can be wonderful to work with other photographers if you are a good fit in terms of personality and aesthetic. You can take more jobs and accomplish twice the workload during and/or after the job. Also, you have options as to how you will split the duties. For example, you could bring a second shooter with you to a wedding to capture a different perspective, use them to help you with lighting and equipment, or send them out on their own wedding so that you can book two jobs simultaneously. Make your decisions based on what best serves the aesthetic you want to provide, your pricing level, and your faith in their skill and personality.

If you don't have extremely capable employees who share the same aesthetic as you, you will water down your product. You will find yourself in a bad place if another shooter's style is dramatically different than your

The number of jobs you take dictates how many people you'll need to help you. Be selective and calculating before you over-book.

Also, teaming up can help you to strengthen your work and book more, potentially helping to build up your local industry, rather than over-saturating the market while you fight for the same bookings.

own and your customer receives a product that does not match what you have shown on your website and in your portfolio. As the business owner, you alone are responsible. If an employee does something that results in bad PR, you will have to handle the repercussions. That's a lot of responsibility for you—and a lot of added stress.

Note, too, that it is hard to find talented people who want to stay loyal to you and not immediately open up their own studio, so you'll likely find a lot of turnover if the benefits of working together do not suit both of you.

POINTS OF VIEW

"I enjoy having a larger studio because you're not always by yourself. You're always working with people and mutually inspire one another in the way you shoot. You have someone to bounce ideas off of, and the pressure isn't always 100 percent on you. And, taking multiple jobs in one day creates that much more advertising for you, as well as profit. Think about it: at every wedding, there are another two hundred potential clients who have heard your name and seen your work. It's nice when you can grow together with multiple people. You choose to hire people to make more money, but they

also bring new ideas and a unique vision to the work."

—*Joseph Priore, www.priorephotography.com*

"If you run a large business, you will have to choose between maintaining employees or hiring independent contractors by the job. Contractors will do their own thing and work for you on the side. I have done it both ways, and I found that, for me, a contractor with a 1099 is more flexible and affordable. They are not totally dependent on me and typically have another job, so that takes the pressure off of me to provide constant pay.

When you hire a contractor for individual jobs, you must understand that they will also shoot on their own. You can't be upset if you're both working weddings, but you have to communicate with one another and make sure you're on the same page. For example, I prefer to have people who don't work for several studios but who work directly with me. I also make it clear that they cannot advertise using images they shot for my studio."

—*Joseph Priore, www.priorephotography.com*

Images by Joseph Priore.

SMALL BUSINESSES

THE BENEFITS

There are many benefits to running a small business: You don't have the pressure of being responsible for numerous employees or providing them with regular work. You don't have the same tax and legal obligations. You can easily work without a storefront. Also, it is easier to maintain your vision of your brand. For perfectionists, it is an enticing advantage to maintain total control.

You can work as a sole proprietor without a studio or you and a partner could work side by side and share duties in a studio setting. A small studio may handle just twenty or thirty weddings a year. In that case, you may need to hire a couple of employees, or have no employees but hire contractors on an as-needed basis. If you plan to work with contractors, you'll need to establish a good network so that you have a group of capable photographers at the ready when you need some help.

Perhaps the biggest attraction to a customer is the personalized service small businesses are able to provide. It is much simpler to offer individualized attention and easier for you to keep track of every client and their preferences. Your sales pitch can be that they are one of only a few customers and that you will attend to their every need. Taking the same approach is not impossible if you have a large business, but it requires more organization and diligence to provide the same individualized attention to clients.

THE DRAWBACKS

If you work on your own or perhaps with contractors, running a small business can be lonely. You'll spend time shooting by yourself and editing alone later. You won't have the option to rely on someone else to get something done if you're falling behind. If you are sick, you won't have people to lean on in an emergency. That is a big potential pitfall in wedding photography. You must have an emergency plan in place or you won't last long in the wedding business.

A way to alleviate some of the drawbacks of running a small business is to make connections with photographers whom you can trust and establish an agreement to help one another out should the need arise. Stay up to date with social networking to make this happen.

It may be an ideal compromise to have one or two solid employees under your belt,

Helpful Hint

If you decide to keep things simple, you should theoretically have more time on your hands because you will take on a limited number of jobs. On the other hand, if you have only yourself to count on and are responsible for 100 percent of the work, you may feel overwhelmed.

A smaller business can be simpler to operate, and there may be fewer surprises. However, profits are usually lower for a smaller business than a large one.

Image by Tracy Dorr.

without immediately jumping into a large business and getting in over your head.

POINT OF VIEW

"Having a home studio has its pros and cons. My husband and I built our home with the intention of having my studio in the basement. We raised the foundation and added windows and a washroom. My full studio space is about 750 square feet, which is the perfect size for client meetings and photographing small shoots. The space is welcoming and is designed to feel light and airy. I find that my clients are comfortable and feel at home. They also feel more connected to me because they get to see where and how I live.

Even though my studio space is separate from my living area, it can be difficult to work from home. I am a wife and mother, and while I may be 'in the studio' I'm still technically home and accessible to my family. My home can feel like a prison at times. When you work and live in the same space, you do not leave work often. At times, I have to remind myself to leave the house for a few hours."

—*Dana Marie Goodemote*
www.danamariephoto.com

CHOOSING A STUDIO LOCATION

A BIG DECISION

One of the most daunting aspects of getting started as a professional photographer is finding a location for your studio. Your location will dictate the type of clientele you attract, how much (if any) walk-in traffic you'll receive, how much of your budget will be devoted to rent, and perhaps most importantly, it will directly influence the overall look of your business. This is a significant decision.

As you begin your search, ask yourself, who is your target client? If you are hoping for high-end sales, you will want to locate your studio in an affluent area. If you want to go after more budget-conscious clients, find a spot that is central to all types of customers. If your desired demographic is young and trendy, you'll want to select a modern, downtown setting. If a country-chic look is more your cup of tea, think about re-purposing a space with character and history, like an old loft, 100-year-old building, or maybe a barn. Exposed brick and vintage buildings may suit your style and aesthetic.

Below—Image by Tracy Dorr. *Following page*—Image by Rachel Nichole.

Consider the commute from your home. Can you drop by on short notice if a customer calls? Will it be feasible to walk or drive regularly, possibly several times in a day? Does it make sense to convert part of your home or build an addition to it?

Some customers don't want to drive to the city or deal with parking hassles, while those in the city will be pleased by the close proximity. Often, people start with what is close to home.

POINTS TO CONSIDER

There are other factors to consider, as well:

- Do you want to be visible from the street? Rent is lower if you are not, but you lose out on drive-by advertising.
- Are you concerned with how people will find you, or do you hope to advertise to bring them in? In many specialties, people will research your business before coming, so your location will have less bearing on whether or not they want to meet with you. Weddings, for example, are such a big, once-in-a-lifetime purchase that clients are far more likely to be willing to travel a significant distance to meet you. Street visibility never hurts, but wedding clients are likely to find you through all types of advertising, including word-of-mouth.
- How much are you willing and able to put toward rent, or do you prefer to buy?
- How far are you from the most popular venues and shooting spots? Being close to a park or other shooting area might be beneficial. If you like the urban aesthetic, you'll want to stay in the city where you shoot on a daily basis. An urban location will also underscore your aesthetic when people come to meet you.
- Where are the other big studios located? Are you too close to the competition?
- How many square feet do you need? What specifically do you plan to do with the space?

As you begin your search, try making a list and ranking your most important needs, followed by things you would like if at all possible. Weigh all of your options against the financial implications and be sure you are making a sound decision that suits your style.

POINTS OF VIEW

"I knew where I wanted to go when I first opened. I drove by the spot for two years prior to signing the lease, and I always thought, 'That would be a great location.' It's a cute, inviting plaza that fit what I was going for. The price was lower than I expected. I purposely stayed a little farther from the main, popular areas to get cheaper rent. The nice thing about wedding photography is that brides are looking for photographers just as much as you're looking for them, and they'll come to you if you're four miles farther down the road. Not being at a main intersection doesn't hurt me because people are willing to come to me."
—*Joseph Priore, www.priorephotography.com*

"When my first lease was up, I thought I would expand to a spot with direct visibility from Main Street. The location I had in mind had three times the square footage.

That seemed very appealing at the time because my business was growing. It was a beautiful spot, but the rent was triple what I had been paying.

I quickly realized that I would need to do more work to pay the rent, and there's a limit to how much you can handle physically and mentally. The new place turned out to have more space than I could actually use; it was so big that it wasn't as cozy and inviting as my old space was. I had the same amount of business located off the road as I did on the main road, because 90 percent of my business is weddings, and brides find me through advertisements or, mostly, word-of-mouth referrals. That large space was beautiful but the higher cost wasn't justified. The same customers were booking with me either way because of my specialty.

In a large space, you pay more in utilities. Since you can only handle so much work, you need to bring more people in to help. I had to find an amount that was comfortable for me.

After three years in the large studio, I returned to my original one, and I've been happy and profitable there for seven years. If your overhead is higher, things are that much harder and more stressful, and that will make you unhappy. You need to factor your happiness into your decision.

I recommend growing slowly. In the smaller suite, I had an opportunity to expand into an adjacent suite and connect them, and I was able to do that after a few years."

—*Joseph Priore, www.priorephotography.com*

Images by Joseph Priore.

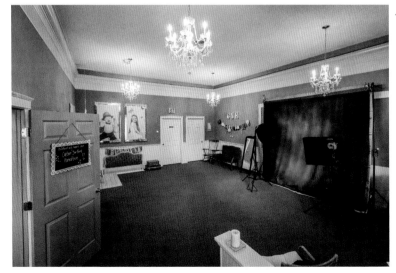

ON-LOCATION PORTRAITURE

BEYOND THE STUDIO

A photography business can be adapted to suit your personal needs. Your style and aesthetic dictate how you will shoot and what your business must provide for you. If your style lends itself to shooting outdoors, congratulations—you can skip the cost and stress of operating a physical studio. You'll use nature as your inspiration, work on location, travel regularly, and avoid studio upkeep costs. Rent is the biggest hurdle. You'll also lack the comforts of a studio when you shoot outside (for example, a place for clients to change their wardrobe, restroom facilities, and a bad-weather option). If you shoot only outdoors, you will face inevitable rescheduling and possible cancellations due to poor weather conditions—particularly if your clients are only in town for a day or two.

Travel is the most challenging aspect of shooting without a studio. Be prepared with a list of familiar potential shooting locations and have on hand samples of photos taken there. Doing so will make you look knowledgeable and help your customers feel comfortable.

Lots of photographers swear by shooting solely outdoors, on location to take advantage of "golden hour" light. They use natural light to create an easy and flattering feel and incorporate local landmarks and places that are meaningful to clients.

GET FEEDBACK

Listen to what your customers want. Do they always ask to shoot outdoors? How often do you think you would use a studio? Are people often asking you for an indoor location or for after-dark appointments?

POINT OF VIEW

"I prefer shooting on location because I love natural light and capturing that golden glow—it makes any shot amazing!"
—*Annie Mitova, www.anniemitova.com*

Left and following page—Images by Tracy Dorr.

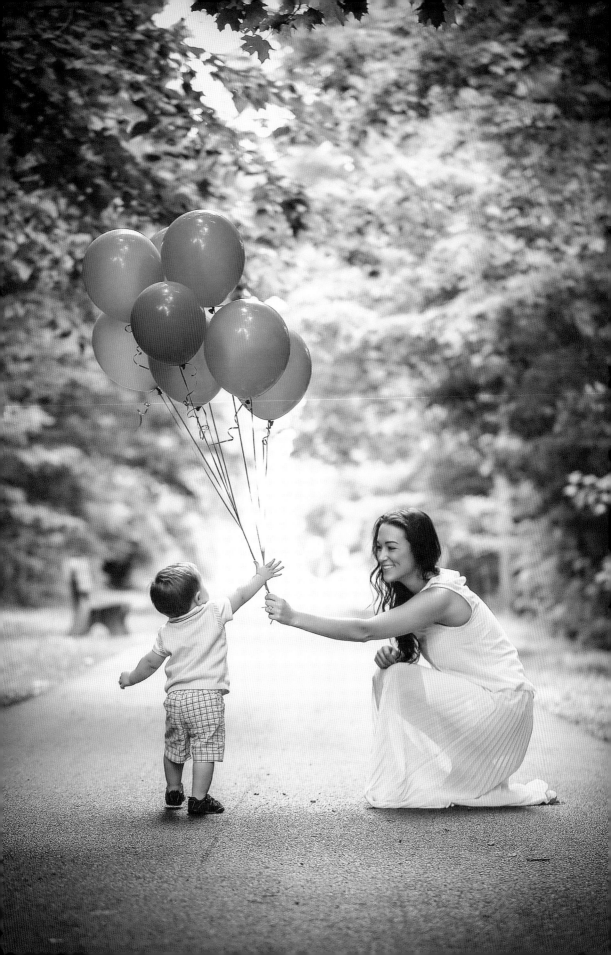

SHOOTING STUDIO PORTRAITS

CREATIVE OPPORTUNITIES

Owning a studio offers tremendous advantages in the variety of work you can create and allows for greater creativity. The props and backdrops that fill your studio will shape the image you promote, inspire new ideas, and lead to a more diverse portfolio.

One advantage that working in a studio has over shooting exclusively outdoors is the opportunity to shoot in any weather or at any time of day. If your client has a baby who naps all afternoon, there's no concern about getting them in by a specific time to take advantage of the best light—they can come when it is most convenient for the family. You can offer longer hours, particularly in the winter when it gets dark early, and you don't need to worry about rescheduling due to rain, strong winds, or cold temperatures.

In the studio, you have total control over the selection of every item, how it will be

Images by Tracy Dorr.

Image by Aileen Treadwell.

used, and how often you will use it. You can continually add new things to your collection. Also, you can design your own sets to create a distinctive look throughout your sessions. Style cohesion is what builds brand identity, particularly when working indoors, and shows clients what makes you unique. If you're the only one who offers certain sets, you will be the clients' number-one choice. Creating a distinctive aesthetic will

Bring the Outside In

Using backdrops to bring the flavor of the outdoors inside is a fun and easy way to infuse your portfolio with variety. Floor and backdrop combo sets allow photographers to use an "outdoor setting" at any time of day, in any weather. Image by Aileen Treadwell. Dress by Enchanted Fairyware. Backdrop by Baby Dream.

Helpful Hint

If you're looking for a way to re-create the look of a favorite location in the studio, take a photograph of a favorite scene and have it produced as a back-drop. You could bring props to the location for the shoot so that they are part of the background (this can save time), or you can add props in the studio for increased variety. Nothing says you can't also make it a habit to shoot outside and embrace the natural ease of nature too. Don't limit yourself to just one approach or the other.

Left—This image was shot on location, using an old door. Image by Tracy Dorr.

Below—This image was made in the studio with a custom backdrop, created from an image of that same door. Now the door can be used multiple times, in any weather, at any time of day, without inconveniencing the owners. Backdrop by Baby Dream Backdrops (www.babydreambackdrops. com). Image by Tracy Dorr.

help you stand out and make your work more memorable.

MY PERSONAL EXPERIENCE

I strongly believe in the beauty of studio portraiture. Controlled lighting allows me to produce flattering images every time, and my collection of sets makes me 100 percent unique in my area. I don't have to compete with other people in the same parks or public spots, worry about weather or lighting, or try to make those areas look different than what everyone else is showing. Everyone has access to the same locations and popular shooting spots, but no one has access to your unique studio location. No one else can offer your specific product.

When a customer walks in, they enter into my world. Everything is chosen to reflect my brand and set the tone, and of course make the client comfortable. You miss out on that ambiance outdoors—you don't get a chance to define your style until after the shoot.

It's really great having everything at my fingertips rather than arriving somewhere and realizing I forgot something. If I get inspired, I just go grab a certain item. If the subject isn't happy with what I had in mind, I can quickly switch to a different set rather

Images by Tracy Dorr.

than trying to force something to work. It's also a huge time saver to not have to load and unload the car every time.

To keep things fresh, I add a couple of new sets every year and find ways to reuse props on different sets so that I'm not doing the same thing over and over. If someone wants me to reproduce a certain set, I can—but I can also offer an individualized look every time. I try to keep the shoots

Image by Tracy Dorr.

I'm not a big fan of the unknown variables involved in shooting on location because it's paramount that each shoot reflects the quality of my brand. My studio provides me with so many options that I wouldn't otherwise have and eliminates the guesswork.

POINT OF VIEW

"I love studio photography because it is controlled. With natural lighting, you never know where the sun will be or what the day will be like until it is time for the session. Backdrops provide endless variety and allow for creativity in your photos. I love that you can create a piece of fine art with a simple Old Master style drop, a fun birthday celebration with a different drop, or a dreamy fairy scene instead.

Carrying props and setting everything up outdoors is a lot of work! Backdrops make it easy for photographers to execute a unique vision in no time. They are an investment, but I find that the more you have, the more customers you attract. Backdrops also let you easily provide a new look every time your client comes in. You can offer three or four options in one session. When you are outside, if you're lucky, you can get two—but that involves traveling to a different location, which takes time. My sessions are sixty minutes, and my clients get three or four different setups in that time."
—*Aileen Treadwell, www.aileentreadwell.com, www.babydreambackdrops.com*

different and rotate through the sets. I do shoot outside too, particularly in the fall, but I've found that our indoor shoots are more popular because it's more convenient for working families. Parents can come in the evening when it is dark rather than trying to take off from work; it is also a great option in the winter when you wouldn't want to be outside—that's a big deal in Buffalo! I coordinate with nap times so that my clients can come in at the child's happiest time of day. I've never had to reschedule an indoor shoot due to weather or change my plans when I arrived because the sun was different than the last time I was there.

An Important Investment

"Backdrops are an investment. Clients are always going to remember their session. If a drop costs $12.00, you can tell in the pictures, and your clients will likely not come back. Invest in some quality drops that will wow your clients. Most of my clients can't believe that all the props are a part of my backdrop. When they see the pictures, they think the subject was photographed in a room filled with props."

—Aileen Treadwell, www.aileentreadwell.com, www.babydreambackdrops.com

TRAVEL

PORTRAITS: PRICING AND PLANNING

Traveling for portrait sessions introduces a number of variables. There are many questions that you will need to answer in order to decide how much to charge and determine which jobs are worth your time. In addition, you must consider the demands of your personal life and the wishes of your loved ones.

Here are some initial questions to consider:

- Will you charge an additional travel fee or include travel as part of your regular price?
- What is the mileage limit for that travel fee? How is a longer travel fee calculated?
- How much stuff do you need to take? (E.g., if you are shooting in a house, do you need to take studio lights, bean bag posers, and a backdrop stand?)
- How long will the shoot take?
- If you are driving and taking large props, will you need to rent a truck or van?
- How much time will traveling take away from your regular jobs? Will it cause you to turn down other bookings? The potential for lost profit should be factored into your price.

Of course, there's a difference between going to someone's house or destination an hour away and flying to another state. Depending on the types of shoots you offer, you may need to pack a lot of props, backgrounds, and equipment, which means more time and effort on your part.

If you travel light and your fee is adequate, a travel fee may not be necessary. If you don't have a studio, be cautious about charging extra because travel is assumed to be included in your fee, as you do not offer an alternative. If you are going to offer complicated setups that involve a great deal of gear, props, or furniture, you can offer various price points for location work.

Aileen Treadwell feels communication is very important on this topic. "I add mileage on and add an extra fee if I have to rent props. I talk with the client before anything is set in stone so they know exactly what to expect," she says. She brings cloth backdrops from her company, Baby Dream Backdrops, which fold neatly so that she can easily take them on a plane.

Pack Your Bags. When you're purchasing your equipment and studio supplies, thoughtfully consider the size of the items you're considering if traveling is one of your goals. If you are flying, check airline restrictions before committing to buy something expensive.

Additional Considerations. So, what factors do you need to take into account when booking a portrait session that you need to travel to? Photographer Aileen

Treadwell weighs in: "Distance. If I can drive, what I can fit in my car. If I fly, how many backdrops I can bring. And lighting—is natural light going to be enough, or do I need to bring my own lights? Where will the sun be when I get there?

I fly to Seattle every year and bring ten backdrops. I book around twenty to thirty mini sessions. Since I do it every year, most of my clients look forward to it. I love doing it, as I get to see the kids grow every year and I also get to meet new people."

WEDDINGS: TRAVEL AT WHAT COST?

When you are considering traveling for weddings, you'll want to ask yourself questions similar to those that portrait photographers face when it comes to travel. What is your time worth? Are you traveling out of state?

Top—Image by Neal Urban.
Bottom—Image by Rachel Nichole.

When you operate a business that books many weddings and commit to travel for a wedding, it's wise to ensure that you are compensated for a few days of your time; this can help you to offset the loss of income from any jobs you may have to turn down due to your absence. If you shoot only ten weddings per year, the potential for lost income is lower. That's one more point to consider when setting your prices.

Here are some additional considerations related to travel: Will you require that all of your expenses will be covered, or just the hotel? Do you need to rent a car? Will

the couple want you to shoot the rehearsal? How much gear is reasonable to bring?

Expect the Unexpected. Careful planning is important. Delays are common—particularly with air travel—so plan to arrive with plenty of time before you start. Since a wedding is a high stress, one-shot deal, you need to try to avoid any potential problems and take back as much control as you can. Consider all possible scenarios where something could go wrong and develop a strategy to increase the odds that things will go smoothly.

Clear Benefits. The benefits of traveling for a wedding are plentiful. You get to explore new locations and can vastly increase the variety of images in your portfolio. It can be also be a creatively rejuvenating experience. Meeting new people helps expand your business into a different market. If people are paying you to travel to their weddings, things are certainly looking good for your business. You have a client who is willing to spend extra for your services and loves your aesthetic.

OTHER GENRES

Some genres require travel. Photographer Drew Zinck says, "Travel is part of my cost of doing business unless I travel more than thirty miles from my house. After thirty miles, I add a fee based upon the distance. I typically follow the guide set by the IRS for write-offs."

POINTS OF VIEW

"I carry a backup light in case of breakage during transport. I do like traveling to portrait sessions. I enjoy offering my services to people outside of my state. I love meeting new clients. Relationships are important to my business, and building

Below—Image by Neal Urban. *Following page*—Images by Rachel Nichole.

new ones is key to expanding my client base."

—*Aileen Treadwell, www.aileentreadwell.com, www.babydreambackdrops.com*

"When I have to travel for a client session, I consider the full cost of the trip, time, location, duration, and client brief. Each session is individualized based on the client's requirements. I do not really plan for anything that could go wrong, but I always have backup equipment with me."

—*Annie Mitova, www.anniemitova.com*

"I love traveling for weddings. You get to see some amazing places. I always ask my clients where the wedding is located. I figure out how long it's going to take and calculate gas, hotel, and food. I charge more based upon distance and whether or not I need to fly. I always get there a day early to check out the town."

—*Rachel Nichole www.rachelnicholephotography.com*

"I'm much more liberal than some photographers when it comes to travel. I include about two and a half hours of travel each way in the cost of my wedding packages. For engagements, I cover up to thirty miles. People have this idea that if they contact you, they don't want to be 'nickeled and dimed' over travel. Weddings and engagements that require farther travel distances are custom quotes for me."

—*Mike Allebach, www.allebachphotography.com and www.brandsmasher.com*

EMPLOYEES

THE PROS AND CONS OF HIRING

The decision of whether or not to hire an employee—or employees—is not only a personal choice, but a monetary one. You might need to hire someone in order to take more work and make enough money. On the other hand, you might prefer to work with someone else simply for the benefits it yields, both in flexibility in scheduling and the talent they provide.

Hiring employees means that you have extra hands to get things done. Also, you can bring other photographers' unique aesthetic to the table. Putting more photographers out on the same day allows you to continue to bring in new business and avoid turning away potential clients.

As mentioned earlier, many photographers choose to go solo. The advantages of working alone basically all stem from having total control. You know exactly what's going on and are present at every event you shoot. You take pride in every aspect of your business. People always know they are hiring you personally and know what to expect. The downside is, when you're all

Image by Rachel Nichole.

alone, you work harder and are limited in regards to how much work you can take on, so make sure you charge enough to ensure you are fairly compensated.

WORTH THE WAIT

If you're just getting started, you'll want to put off hiring anyone until you're making enough money to afford the expense. As you continue to grow, you can bring someone on to help— either a photographer or someone to set up appointments, edit, and run your day-to-day business. Your profit margin must remain high to pay them. That may result in added stress for you. You'll owe employee tax and you'll have another person dependent on you, so it is likely you'll see lower profits for a time. You'll also need to consider whether or not to offer heath and dental insurance. Employee benefits can be expensive, and prices typically go up over the years. This makes your commitment to them even more substantial. Plus, no one relishes having to fire someone, and hiring can be a tedious process when you're looking for the perfect complement to your personality and your work. A discussion on tardiness, dress code, or attitude is never easy for anyone. If an employee makes an egregious mistake out

Image by Dana Marie Goodemote.

on a job, that will reflect poorly on you. Whomever you put out on a job under your name must reflect your business ideals.

Put in some careful thought before hiring. When you advertise a position, be specific as to what will be required to make the relationship work long-term. Once you select the person, communicate effectively to be sure you're on the same page about

Above—Image by Tracy Dorr. *Following page*—Image by Aileen Treadwell.

how you conduct business and what you expect. Having an employee who meshes perfectly in your company and with your work ethic can be extremely advantageous.

MY PERSONAL EXPERIENCE

Working side by side with someone else can have a profound effect on both of you. Even though it forces you to release some control and compromise from time to time, it yields a broader and more substantial vision for your photography business. Each of you will bring different things to the table, and what your partner contributes will shape and redefine your future in ways unforeseen. Your vision of your craft adapts and evolves with the depth they bring. As you merge your personal aesthetics, you gain strength and cohesion in your united vision; you realize that you have headed in a direction you hadn't imagined yourself pursuing before you met them. Then you realize it is a perfect fit, the missing element you didn't know you lacked.

THE RIGHT EQUIPMENT

GEARING UP FOR WEDDINGS

It is extremely important that you use good, quality equipment when you photograph a wedding. Without it, you won't be able to provide a decent product worthy of the price and glamour of the day. Gear-related expenses can seem astronomical, but making the investment is necessary to ensure that your work looks professional and clean. You'll also need to use quality equipment to justify charging what your competition is charging. If your camera or lenses are sub-par, you will suffer from bad word-of-mouth and no referrals, which can be nearly impossible to overcome. You'll also need to ensure that you have a backup for every piece of equipment you need to do your job in case there's a problem on the wedding day. There is no second chance.

Pack Smart. It is important pack gear that will allow you to produce great images in any scenario. Some churches are very dark. Be prepared with fast lenses and bodies that are capable of handling low light with minimal noise. You may find that you're shooting outdoors, in challenging light. If so, flash and modifiers can help. If you're shooting an outdoor reception and rain moves in, you'll want to have on hand waterproof accessories and umbrellas. A simple plastic grocery bag is a quick and easy solution for protecting your gear so that you can continue shooting and avoid a pricey repair bill. Zoom lenses help you get closer views of your subjects and can minimize intrusions.

If you have employees, you will want to decide whether or not you will provide their equipment. If you do, purchase professional-grade equipment to allow them to succeed.

Image by Tracy Dorr.

Images by Tracy Dorr.

PORTRAIT EQUIPMENT

A portrait session may not be a once-in-a-lifetime shoot like a wedding, but your reputation is always on the line, so it is important to consistently provide the highest-quality product. Customer expectations are high, and you will need to present quality work to please them.

In portraiture, your equipment choices are highly personal. You'll need to consider whether you plan to shoot in a studio or on location, with natural light or with strobes. Those decisions will dictate your purchase needs. Certain lenses, like an 85mm, are designed for portraiture and may be a good first choice. A good wide-angle lens is necessary for a big family portrait. You may need lights, backdrops, stands, reflectors, wireless triggers, and tripods—and perhaps an assistant to help you handle them. As you develop your technique, choose the options that work for you in order to achieve soft, pleasing light and the most flattering skin tones.

If you shoot exclusively outdoors, determine what you will do when you are faced with less than ideal lighting. Also, outline a policy for bad weather and decide in

advance how you will notify clients if there is a change in plans.

Unusual Equipment. Selecting the right lens for a portrait is important, but having the tools available to adapt to any situation is key to success. Props are tools which can often function as equipment to help you provide variety in posing, overcome problematic lighting, or help a client relax.

A MATTER OF PERSPECTIVE

It's interesting to interview experienced photographers and learn about the equipment they can't live without. No one chooses the same equipment, any many have innovative ideas for using things in ways you may never have considered. As you build your equipment arsenal, keep informed about updates in equipment every year, and ensure that any new gear you purchase enhances your brand.

POINTS OF VIEW

"In order to select the right equipment, I consider location, light, and the purpose of the shoot. There is not a single item I can't live without. I am a strong believer that although equipment matters, it is not the most important part of the process."
—*Annie Mitova, www.anniemitova.com*

Image by Aileen Treadwell.

Image by Tracy Dorr.

"I invest in all of my equipment. Yes, you can get most things cheaper, but things are cheap for a reason. They don't perform the best. I try to upgrade my camera every two models. I have a bunch of lenses, but I swear by my 50mm f/1.2—it never comes off my camera. I never change up my set in the studio; I always have my strobe in the same exact spot. I shoot with a huge octagon softbox behind me to my left, and a huge reflector to my right next to my subject. I love controlled lighting!"
—*Aileen Treadwell, www.aileentreadwell.com, www.babydreambackdrops.com*

"For how much a customer is paying, quality is most important. You get different results depending on the lens and lighting you choose, but you need a good camera to provide a professional product. If someone is paying you $3000, your camera needs to have the capability and quality to match."
—*Joseph Priore, www.priorephotgraphy.com*

"I can't live without my Canon 24–70mm lens. Nearly every image I have taken was shot with that lens. For weddings, I can't live without my assistant (husband). He helps me with the bride's dress and holds all of the things that I need."
—*Rachel Nichole*
www.rachelnicholephotography.com

EQUIPMENT FAILURE

WHAT IF ... ?

There is a cardinal rule, especially concerning weddings: Whatever can go wrong will eventually go wrong. If it hasn't broken yet, it will in time. Being ready with back-up equipment is critical for any photography job. Have two of everything and test your equipment before every shoot. Some cameras can record images to two cards at once; this is a nice advantage that may allow you to avoid enduring an image-recovery procedure.

It is important to know how to handle problems as they arise. Stay calm; don't panic. If the customer sees you freaking out, they will too. It will damage their confidence in you. If you drop something or something breaks, take a deep breath, say "Hold on a second" and move along to your backup equipment. If a card malfunctions, set it aside and use a new card. Don't do anything to it until you review it and try recovery software. If you get an unknown error, switch camera bodies. If you drop a lens, put it away, take out another, and assess the damage later.

When you have time and are not standing in front of a waiting client, troubleshoot the problem before giving up. It might just be an oversight on your part. For example,

Image by Tracy Dorr.

if your exposure meter was too high, or your flash is not working because it's on the wrong setting, things will look bad but will be fine. Nine times out of ten, it's just something that needs to be adjusted and not a gross malfunction, and because you're working fast, you didn't notice and worried that your gear was broken. During a ceremony, there is no time to investigate. When you have a minute, check your settings to see if something was inadvertently changed.

JUST KEEP CALM

Remember that equipment repair is part of the deal. Things break, and most of the time, they can be repaired. That's just par for the course when you are a professional and using your equipment often. It is wise to factor repairs into your yearly budget. This will help provide you with peace of mind when something goes wrong. It's like car repairs; it should come as no surprise that you will eventually have to fix something. It happens.

POINTS OF VIEW

"Always have two sets of backup gear. I carry four cameras, at least six lenses, and three flashes, just in case."

—*Frank Priore*
www.priorephotography.com

"One time my shutter broke right before the bride was about to come down the aisle. It was making a lot of noise, so I quickly removed the battery to stop it and grabbed my backup camera so that I didn't miss anything. It happens to everyone eventually. Don't panic and forget you have it.

Image by Tracy Dorr.

Don't try to figure out what's wrong with your equipment at that time. Just keep moving. The last thing you want to do is worry a bride over equipment failure—you have your backup equipment. That's what it's there for."

—*Joseph Priore, www.priorephotography.com*

HOW TO HANDLE PROBLEMS

GUEST BEHAVIOR AT WEDDINGS

Sometimes good intentions and good people get out of hand. If a wedding guest falls victim to this, you will need to be professional when you react. If you feel you are being harassed, know when and how to take action, and when to let it go. This is best learned by experience, either on the job or by talking to other photographers who have faced a difficult encounter.

Try to resolve the issue quietly or remove yourself from the situation. If you cannot resolve the problem, try talking to a parent or wedding party member—or the bride or groom if the situation warrants it. Luckily, these types of instances are few and far between; it's not likely that you will face them often.

It is a good idea to outline your protocol for handling problem behaviors in your contract so the couple is aware of what you expect. Should a conflict arise, keep a written log of what transpired. You do have the option to add a decency clause in your contract. This would state that you are not required to put up with any behavioral issues that may occur. This usually is not a major point; removing yourself from a bad situation is always the preferred way to diffuse it. Be as assertive as necessary to put a stop to a bad situation and remind people that you are in charge in order to regain control over the group. Of course, you should never get into a fight and must not stay if you are in danger.

My Personal Experience. You are always going with the flow on a wedding day. If a guest's behavior is changing the day or impacting your work, you have to be ready to react quickly, offer alternatives on the fly, and adjust to the scenario as it unfolds.

At a certain point in a bad situation, you will feel your control slipping away—and it is at that time that you must act in order to get it back. If you have a big group that is being unruly, complete the minimum pictures you need with them and send them back to the limo to have fun. Once it is quiet, you will be able to regain your composure and spend time doing a great job with the bride and groom. You need to make sure that they get what they are paying for.

If things are generally going terribly or one person is causing a delay, start thinking about your options and choose a "plan B" well before you need to execute it. Try to spot the problems and figure out how you will respond. The bride will look to you if things are falling apart, as no one expects things to go badly and they don't know how to salvage the situation. Brides put

*Following page—*Image by Rachel Nichole.

their trust in your experience so that you can guide them through lousy situations and choose the best option.

Points of View: Guest Behavior. "I once had a bride who was drunk when we arrived. She was obnoxious and rude to every vendor the whole day. She walked away in the middle of pictures, so we gave her space and tried to be patient. We let her know we were there whenever she was ready. During family formals she was so drunk that she kept interrupting my other photographer and saying that we hadn't taken pictures that we had already taken. My photographer kept repeating calmly that we had taken them, and when the bride kept insisting we had not (even after we showed her some images on the camera), we sucked it up and took the pictures again, without complaint.

In order to try to keep control, we kept calmly asserting ourselves and tried to keep things on track, until the groom asked us to let it be. At that point, it's up to the clients to decide how they want to spend their day. We did our best by using a candid approach. We also switched off to relieve each other so that no one lost their temper. We wanted the bride to enjoy her day, but we needed some control over those formal photos. Since we also shot video, we had documentation of how things actually happened in case we needed it, but we didn't."

—*Joseph Priore, www.priorephotography.com*

UNREASONABLE CUSTOMERS AND POOR REVIEWS

Most photographers will eventually face an unhappy customer. The more volume that you handle, the more likely it is that someone will find fault with something or you will have a bad personality match with someone. It's just the nature of customer service, and it is important to listen to what they are saying without taking it too personally. Try to respond directly to the client and rectify their problem.

In an ideal scenario, the client will bring their concerns to you, and you will be able to address their needs and ensure that they leave happy. Of course, there are those who will turn to social media to voice their frustration before or instead of speaking with you, or may post bad reviews. If a client blindsides you by speaking badly about you or your business in a public forum, then you can usually craft a professional, kind response that tells your side of the story.

Luckily, this is just a tiny element of the business—and one you one often encounter. Do your best in every interaction and always try to be fair. The good will outweigh the bad.

The Fix. Many problems can be fixed. If there's an issue with a single image, you can use postproduction to crop, straighten, brighten, or remove extraneous details. If it's a question about a missing image, offer to include a guest's photo in the album, look over your originals again, or offer to re-shoot the desired image if possible. If your clients are dissatisfied overall, offer to work with them on their album or prints. Offer a full or partial refund only as a last resort. Refunds should only be offered if you were in the wrong to avoid setting a dangerous precedent.

The Importance of Communication

"One thing I have learned over the years is that clients want direction. I feel that good communication between you and your client is the most important component in a working relationship. Clients don't know what happens next or what to expect. It's our job to tell them. It's important to guide them through the process; you can't expect them to know what to do next if you don't tell them.

We guide our clients through the pre-planning of their day, to the last steps of picking up their beautiful wedding album. We begin by giving them a welcome packet filled with step-by-step directions. It includes: a wedding-day agenda; a to-do checklist that starts twelve months before the wedding; a post-wedding instruction kit; our studio policies; a bridal beauty guide; a guide for the groom; an engagement session kit; payment plan info with payment dates; copies of contracts and invoices; and additional informational pieces.

This packet is their go-to resource for any questions they may have. We also have three in-person meetings before the wedding and an order meeting after the event. On average, we see our wedding clients five times within their wedding process. This may seem like a lot, but we find that the more face-time we get with our clients, the more they trust and love us. Our goal is to build relationships with our clients that will last far beyond their wedding day, and give them an unforgettable experience from start to finish. I feel our welcome packets help further our brand and position us as experts in our field."

—Dana Marie Goodemote, www.danamariephoto.com

Some people only complain to get something for free. If you feel this might be the case, offer an inexpensive product as compensation first. Never argue. Hear them out first and use understanding and compassionate phrases like, "I understand how you feel, and I am sorry for any confusion." Statements like "Your happiness is of the utmost importance to me" or "I would like to rectify this problem" can go a long way toward realizing a lasting resolution.

Points of View. "Online, anything is like the flip of a coin. Bad reviews can easily pop up and put a damper on future business. Be ready for the good, the bad, and the ugly. Be prepared to answer questions from prospective customers. Stand by your work."

—*Frank Priore, www.priorephotography.com*

"Usually you can feel when a customer is going to clash with you early on in the process. You get a vibe through your first few interactions. Once I had a bride who was unhappy before we even shot her engagement photo. Our policy is that it is completely up to the customer to decide when they want us to shoot their portrait, but she felt that it was my responsibility to choose for her. I tried to correct the problem when she called. I explained that it's always up to the bride and groom to decide when the portraits are made and told them I would be happy to do whatever they liked. We shot the engagement photos, and she nitpicked over every image. I did my best to understand, but she was already asking for extra prints and extra discounts. So for the wedding, I told my photographers to write everything down and keep notes if anything

went wrong. Sure enough, after the wedding, she called to complain and used the same line, word-for-word, for a third time about being 'disappointed.' She wanted to know what they were doing at every moment of the day, and all of her complaints were fabricated. Luckily, I had time stamps from the metadata on all of the images, and combined with the notes my photographers took that day, I could go through and prove what had really happened. I defended my photographers who had worked very hard for twelve hours and taken 3000+ pictures. Once I took a stand, she backed off. Really it was all about getting free things, and when she knew that I stood by my staff and our product, the situation was diffused. This doesn't always apply, but it's important to know when to stand up for yourself and when to give in."

—*Joseph Priore, www.priorephotography.com*

"You can't control online reviews, so I try not to pay too much attention to them. We have a very good rating and do a lot of volume, so eventually we're bound to get one, regardless of giving clients our best. It's impossible to make every person you meet happy. I feel all of the good reviews and referrals outweigh that one bad one."

—*Joseph Priore, www.priorephotography.com*

WEDDING GUESTS/FAMILY VYING FOR CONTROL

Losing control at a wedding can have a catastrophic impact on your business identity. When you capture family photos, there are a lot of interested guests around who are not only taking pictures, but offering

suggestions. Forceful personalities will sometimes try to take over and start posing or start organizing the next shot. In such situations, it is important not to be antagonistic or escalate the situation.

Joseph Priore says, "I work very quickly, which doesn't allow guests time to really assert themselves or get in to do anything. At the end, I ask if they would like to take a picture before moving on. You can use the phrase 'I'm sorry, we're on a tight schedule' if anyone is becoming a problem. That gently prods them out of the way and reminds them that you're in charge."

Never touch or push anyone or tell them to get out of the way. Remember that it is not your day, and that the guests have a right to be there and enjoy themselves. Some photographers will tell guests "I am the only photographer here, and you can't take pictures," but that can come off as callous and rude. Let them have their fun, so long as it doesn't critically impact your work. Make sure to reiterate to the bride and groom that you want their full attention, and that they should look to you for photos. This helps alleviate the problem of many people looking in different directions at all of the different cameras surrounding you. Keep repeating, "Look over here, eyes on me." When you are done, stand back and let everyone else have their turn. Gently remind people of what is coming next, but don't be afraid to use an authoritative, louder voice to maintain control. Being too soft spoken makes you appear confused, unsure, or unqualified. That makes people want to jump in and direct to help out.

My Personal Experience. Everyone wants to have fun and enjoy the day. If guests are asking for pictures, I take the picture and move along as quickly as possible. Just because the picture they want doesn't suit my taste doesn't mean it isn't important to them, and they're a big part of the day, so I always take what they ask for.

Almost all complaints are due to a failure of communication. If it happens to you, try to resolve it and move on. Go over details and requests thoroughly before the event in order to make sure that you touch on everything they want. Ultimately it's about giving them what they want; it's not about me. When I am accommodating, people are generally pleased that I was willing to listen, and they are happy with the final product, even if I sacrifice a tiny bit of aesthetic control.

Points of View. "At a wedding, most guests are friendly and polite. If I ever encounter a problem, I know I can go directly to the bride and groom if needed. I have a copy of the wedding contract with me at all times, just in case. But first, talk with the person who is causing a problem. If that's a no-win, then talk to the bride and groom."

—*Frank Priore, www.priorephotography.com*

"I always try to show that I'm in charge. I have the next idea ready and I move quickly, so I don't open the door to someone who thinks I'm unprepared. If I have to say no to something, I explain the reason why."

—*Joseph Priore, www.priorephotography.com*

UNPAID CUSTOMER BILLS

As a professional photographer, there is a good chance that you'll occasionally have to deal with a non-paying customer. To try to offset any problems, be sure that the client's financial obligations are stated clearly in the contract. Also, send an invoice as a reminder prior to the payment due date. If you are down to the last days before an event, you must speak to the client to get confirmation of everything.

Once a payment is past due, send a hard copy of your invoice through the mail and/or place a phone call. If they don't want to pay in advance, putting a credit card on file is a good protective move.

Pictures should not be released until final payment is received. This is paramount in weddings because once the day is over, the excitement fades and any urgency a client feels to pay the bill dries up. Most vendors require payment in advance for a wedding for this reason, but if you're willing to accept payment after the event, then you absolutely cannot release your product until payment is received.

Resolving the Issue. In most cases, you will not need to take legal action to resolve the issue of nonpayment. Talking to your clients and reminding them of what is in their contract may help. That said, if your payment policies are outlined in your contract, you'll probably fare well in the unlikely event that you must take legal action. The best approach to resolving the issue of nonpayment is to be flexible in order to maintain good customer relationships. Playing hard ball should be a last result, as it can result in poor word of mouth.

Laying the Groundwork for Success. Your payment policies may be different for portrait or commercials jobs. For example, big businesses are used to having invoices sent to their accounting department and paying after the images are delivered. Requiring a deposit for a portrait session will give you some protection if people do not place orders or neglect to make their payments. Consider all of your options, and then decide how you feel most comfortable proceeding.

Point of View. "It's rare that I get an unpaid bill for a wedding since we require all payments up front. If people are uncomfortable with that, we discuss it and find a solution (e.g., paying upon pickup or something). If you are taking a new print or album order and must front the money for them product, then I recommend asking for a credit card when the client places the order so that they come back and you don't lose money."

—*Joseph Priore, www.priorephotography.com*

"Over the years, I've learned that people can be slow to pick up their print orders. I've changed my policy from paying upon pickup to paying upon placing the order. That way, the product can sit and wait for them, and it won't bother me."

—*Joseph Priore, www.priorephotography.com*

MISMATCHED EXPECTATIONS

Image tastes are extremely subjective and so, you will eventually encounter someone who expresses some displeasure over some aspect of the images you create.

For portrait sessions or commercial work, you have the option to offer a re-shoot if your client doesn't like their hair, expression, or the lighting. Detail your re-shoot policies up front in order to protect yourself. Where weddings are concerned, things aren't so simple. Since you can't go back and re-shoot a momentous occasion, you need to communicate effectively ahead of time, use common sense, apply caution when necessary, and cover your bases from the start.

At some point, you're likely to encounter differing opinions between brides, grooms, and their parents. If you find yourself stuck in the middle of an argument between a couple and their parents, do your best to offer enough variety to please both sides. For example, if the bride wanted lots of black & white images, but her mother didn't like them and felt they look dated, things will be tense and awkward. A simple solution is to offer to provide the black & white images in color as well, at no additional charge. That way, both parties get what they want. Taking that approach costs you time, but it shows you're willing to compromise and listen to deliver a product everyone will be satisfied with. Of course, this means you will

need to plan ahead and save your original images before converting them to black & white in postproduction. Save your edited files under a new name and always save backups. Cover your bases so that you can offer a solution to the problem.

Now, let's say that the problem presents itself before the wedding. The bride's parents want a bunch of pictures, but the bride and groom tell you that it's *their* day and they don't want to spend time shooting the pictures that are being requested. Regardless of who is footing the bill, if you don't satisfy both parties, one will bad-mouth you to anyone who will listen. In my experience, if there is a problem between the bride and groom and either set of parents, they will not communicate with each other to find out if one of them had requested you do things a certain way. The bottom line is you will be blamed. They will not go easy on you because you tried to be kind and please the other person. If you find yourself in this situation, you have a couple of avenues to pursue. Consider providing an image-request sheet prior to the wedding with all of the typical shots (and the shots in question) listed on it. Ask the bride to initial any of shots on the list that she is refusing so that

Helpful Hint

When asked to ignore a certain person at a wedding or cut them out of pictures, proceed with caution. Your best course of action is to take a couple of shots anyway, then pull them out of the final folder. Save the shots, however, in case someone calls you and asks why you didn't take their picture at all. In the end, you are responsible, and you alone have to answer to any issues, no matter how good your intentions. Think carefully about each decision you make and try to offset any potential negative consequences that could result.

her wishes are documented. This functions like a contract and offers some protection. The other important thing to do is try to find a way to compromise on those particular shots. For instance, if the mom wants a picture with everyone, including her cousins, but the bride doesn't want to take it, you could offer the mom a picture of her and the cousins (without the bride) and an individual shot of each as well. You will also want to take care to ensure that those people are well represented, even in candids, to satisfy her need for them to be included. If you ignore the situation, the mother might be upset that you did not capture the entire family on a special day and think that you are to blame. If both parties are cordial, you can present your compromise to them before the wedding and see if they are both pleased.

In My Experience. Sometimes there's a no-win scenario, and all you can do is conduct yourself with integrity and capture the day the best you can. For one wedding I was hired to shoot, the bride and groom wanted totally different things. One wanted tons of pictures and the other didn't want any at all. No matter what I did, someone wasn't going to be pleased with me. They never agreed on a compromise, so it was up to me to figure out how to proceed. All I can do in that scenario is be as friendly and easygoing as possible, and sneak in photos as often as I could without bothering anyone. It's hard as you're fighting yourself all day because you want to give the clients your best every time. You want the experience to be magical every week. It can be painful to censor yourself, but the bottom line (which you learn over time) is that it's not your day, and it's not your vision of the day that really matters. The reality is that there is an awful lot going on that has nothing to do with you, but it is your job to make things flow as seamlessly as possible in spite of everything. Conflict is stressful. It's like shooting with one hand tied behind your back. You're never thrilled with that type of situation, but a professional will deliver a great product no matter what, and in the end, I did.

Points of View. "At times I have used a sign-off sheet at pickup. I would answer all of the client's questions and go over the photos. If everything looked okay, the bride and/or groom would sign off. If the bride and groom are happy at pickup, then the parents should be okay. I also have them initial the request sheet if they do not want certain images taken."

—*Frank Priore, www.priorephotography.com*

"When I am faced with a conflict, I remember that the bride and groom are my clients, and I always side with them. I'm there to capture the day, not to control the day. If the parents want something different, I believe they need to ask the bride and groom. I'll do whatever the bride and groom want."

—*Joseph Priore, www.priorephotography.com*

FIRST IMPRESSIONS

LOOK THE PART

First impressions mean a great deal. Here are some key things to remember to ensure that your clients' initial impressions of you are favorable.

- Dress the part. You never know when someone will stop by to meet you, so it's best to always look professional.
- Make sure you're completely knowledgeable about all of your packages and the photography experience the client can expect while you are on the job.
- Know what makes you stand out from your competition.
- If you're meeting in a studio, make sure it is clean and looks its best.
- If you're meeting the client somewhere, arrive early. Never be late.
- Listen to your customer. Find out what their needs are, try to be helpful, and offer advice based on your experience. Avoid telling them what they want.

TRUST YOUR INSTINCTS

Though you are hungry for work, don't take a job if you have a bad feeling that a client is not a good match for you. Simply tell them, "I don't think I'm the right photographer for you." Heading off potential problems is important. With experience, you'll be able to identify what's about to happen before it does. Maybe you can correct issues with good communication. If you feel your personalities may clash, it might be better to avoid taking the job rather than to risk suffering the consequences of poor word-of-mouth and bad reviews for years.

A good first impression lasts far beyond the one person you're meeting with. All of the referrals that clients send your way stem from your initial interaction. Put your best out there.

POINT OF VIEW

"When a client contacts you, they likely have seen your work online or have been referred by a friend and are just coming to see you in person. At this point, you need to seal the deal. It's important that your studio looks clean and impressive and you look the part. Send the impression that their day means a lot to you—that it's more than just a job. Show that you truly care about their day and you enjoy what you do. I ask a lot of personal questions and I learn as much as I can about the client's day rather than presenting my portfolio and saying, 'Here's my work.'"

—*Joseph Priore, www.priorephotography.com*

CONTRACTS

THE NUTS AND BOLTS

Establishing and using contracts is one of the most confusing parts of starting a photography business. When do you need a contract? How do you make one? What does it do for you?

A signed contract ensures that both parties are on the same page; it also serves as a reminder of what you've agreed upon and protects both of you. If there's a problem after the shoot, you'll know when to stand your ground and you'll be able to back up your position. Without a contract, you will face a more difficult legal battle should a serious conflict arise.

For example, if your clients cancel their wedding and want their deposit(s) back, they may take legal action against you. Deposits are taken for a wedding in order to protect the studio or photographer against cancellation. After all, if you have reserved that date for a year or more, you will have turned down potential business for that day. If the client cancels at the last minute, you won't have time to re-book the date and you would be out hundreds or thousands of dollars in profit. When you draw up a contract, both parties agree to the payment schedule and the consequences of a cancellation. It helps them understand your reasoning behind saving the date early and ensures there are no surprises.

A contract isn't only for you; it simultaneously protects the client. You're giving your word that you will show up for the event and provide the agreed-upon services. If you fail to provide what is set forth in the contract, you can be held liable for a breech of contract. This gives your customer peace of mind. They know that you are legally bound to do what you have agreed to do. This can help ease worries, particularly when they are putting money down one to two years prior to an event. That's a long time to worry and wait, and that thought alone may prevent them from booking without the added assurance that a contract can provide.

DIY OR PROFESSIONAL HELP?

There are several options available to you when creating contracts, depending on your

Helpful Hint

If you are making your own contracts, double and triple check the spelling and grammar. Your professionalism is being judged by these words, and it's important to get it right.

personal preferences and the type of job in question. You can buy contracts, often as part of a photography program or through a legal website. Marybeth Priore Mantharam, Esq., advises, "If you are doing it without a lawyer, a pre-made contract is the best way to start, and you should modify it to fit your needs."

If you decide to seek the services of a lawyer, Mantharam says, "Corporate lawyers are usually the best for drafting and/or reviewing contracts. They often have intellectual property experience that will aid in the copyright provisions. Litigators are also useful allies because they will be handling your lawsuit if there is a breach of contract. You can start by Googling a corporate lawyer in your geographical area. Another good way to find a lawyer is to ask people you know and trust if they have someone they would like to recommend. If you know a lawyer or have used a lawyer in the past, they may be able to refer you to a corporate lawyer. Lawyers often take initial inquiries by telephone and e-mail. You should not be afraid to ask right away what the lawyer's hourly or flat rate will be."

WHAT TO INCLUDE

A foolproof option is to have a lawyer draw up your contract so there are no surprises and you are assured of quality content. Before you consult with a lawyer, ask yourself how specific you want/need the contract to be. Try to make a list of what you want included before you meet with the lawyer so you're not thinking about these decisions for the first time when you get there. Do you want the ability to edit the contract

in the future? Do you want to add more personal points to address things like behavior or dress code, or should the contract be more general and center on providing services, payment schedules, and file ownership? What do you want to include for deposit, cancellation, and refund policies?

Contract Clause Example

Here's an example of a real wedding contract clause:

It is understood that this studio is the exclusive official photographer retained to perform the photographic services requested in this contract.

No part of any order will be delivered until the balance is paid in full.

The studio reserves the right to use images and/or reproductions for display publication or other purposes. Images and previews remain the exclusive property of this studio.

In the event of postponement or cancellation of the wedding/contract, payments made are not refundable.

Travel fees may apply for some locations.

Dinner for photographers must be provided.

If there are any changes in the schedule, notify us immediately.

Full-day coverage is approximately two hours prior to the ceremony through all of the main events of the reception.

Coverage ends no later than 11:00PM, with twelve hours maximum coverage.

The studio takes the utmost care with respect to the exposure, development, and delivery of photographs. However, in the event that the studio fails to comply with the terms of this contract, due to any event or act outside of the control of the studio, the studio's liability is limited to refund of deposits.

—Courtesy of Priore Photography & Video
www.priorephotography.com

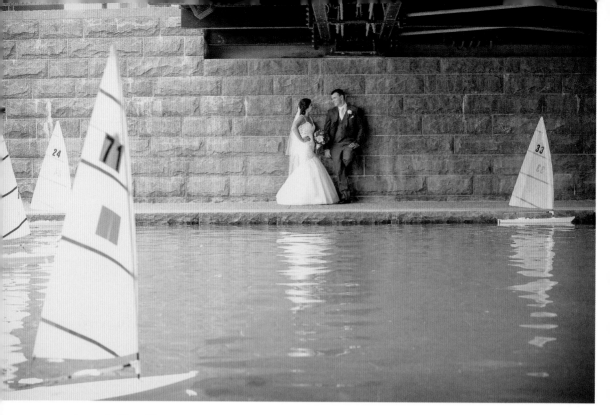

Image by Tracy Dorr.

Additional expenses like travel should also be addressed. It is also common to include in the contract verbiage that states that you will be the exclusive photographer at the event. Again, it is extremely important to state your refund policy. It is critical that your client is informed from the start. Coverage, whether minimum or maximum hours and your terms for overtime, should also be addressed.

KEEP IT UP TO DATE

Make updating your contract part of your yearly to-do list. Marybeth Priore Mantharam, Esq., advises, "You should review your contract annually to make sure it covers recent updates in the law and in society (e.g., social media advances)." The best way to avoid conflicts and save time is to stay abreast of the need for changes to make sure you are always covered.

HIRE AN ATTORNEY

Marybeth Priore Mantharam, Esq. states, "Hiring an attorney to draft and/or review a contract is highly recommended. An attorney will make sure you are covered from a liability standpoint. Another benefit is that the contract will hold up if it is ever the subject of litigation. Self-drafted or form contracts may contain problematic language that you might not be aware of. In some situations, this can result in the whole contract being declared invalid. It is good to have peace of mind knowing that a professional has drafted your contract for you. However,

if you cannot afford one or choose to do it yourself, pay attention to the following (note that this is not an exhaustive list):

- Do entitle the document "Contract" so there is no confusion as to its intent.
- Do identify the parties with their full names and addresses.
- Do date the contract.
- Do use numbered paragraphs and plain language for ease of reference.
- Do define all technical terms.
- Do read every word of the contract (including exhibits) before you sign it to make sure you understand it.
- Do make sure both parties read and sign the contract and have copies of the fully executed version.
- Do understand what a copyright is and identify in the contract who the owner will be. If you took the photographs, you own the copyright. If you are selling the copyright, make that clear.
- Do make payment terms and schedules very clear.
- Do include a section on hours of work and provide a firm start and exit time.
- Do include a section on what will occur in the event of an emergency when the requested photographer is unavailable.
- Do include a section on what will occur if the wedding (or event) is postponed or canceled.
- Do be clear on what you will be delivering. This is often done by identifying pre-built photography packages.
- Do be clear on the date on which you will deliver the photographs.

- Don't include overly long sentences. Rather, break them down into easily understood parts.
- Don't be repetitive unless absolutely necessary. Rather, refer back to a previous provision by its paragraph number.
- Don't include meaningless language or phrases.
- Don't assume the other party defines a term the same way you do. If there is any ambiguity, include a definition in the contract.
- Don't rush. Take your time in preparing and reading over the contract so that you completely understand it.
- Don't agree to a modification of the contract unless it is memorialized in writing."

POINTS OF VIEW

"I feel contracts are very important for weddings because that's what you fall back on when a customer is trying to take advantage of you—and there will always be one person looking for a loophole if you do enough business. You'll come across all types of customers, and it helps to be prepared. I make changes to my contract every year in response to potential problems that I can see coming."

—*Joseph Priore, www.priorephotography.com*

"Contracts are really important, not just for the photographer, but for the client as well. It helps my clients to know what to expect from their photo shoots. It also guarantees that I will get paid, and the client can rest assured that I will show up."

—*Rachel Nichole*
www.rachelnicholephotography.com

LEGAL ISSUES

LEGAL ACTION AGAINST YOU

Hopefully, you'll never find yourself on the receiving end of legal action. Remember to protect yourself and be clear and honest throughout the whole process for every job. Your policies and deadlines should be clearly stated in writing.

Communication is your biggest ally. If you sense a problem forming, head it off before it snowballs. Talk with your customer (at great length, if needed) in order to find an equitable solution to whatever the issue is. It is always easier to fix a problem before the shoot than it is to fix it after. Being clear and thorough takes the guesswork out of most conversations and eliminates the majority of misunderstandings. After all, most complaints arise from a simple misunderstanding. Do whatever you can up front so that you don't invite trouble.

TIPS FOR AVOIDING LEGAL ACTION

With some planning and preparation, you can diminish the likelihood that you'll find yourself in hot water. Consider the following points to keep trouble at bay:

- Write everything down. Include reminders of phone conversations or meetings with your client. Attach photos of things they have shown you that they like. If you are unclear about what the clients are saying that they want, pull pictures from your portfolio that you feel are similar to what they are describing and gauge their reaction to them. Try to show your own work (rather than Googling or using Pinterest). This conveys to the couple that you've been to the location before and you've shot something similar to what they're asking for. This inspires confidence in your skills when they see that you can provide examples of what they're describing. Having a paper or digital record of each client's preferences on hand also helps jog your memory and keep you on track.
- Have every client read and sign a contract.
- Have at least one personal consultation before an event. This is particularly important if you will be photographing a wedding or large event.
- Ask lots of questions. What style of images is the couple looking for? Are there specific shot requests? Is there anything they are unclear about? What are they most looking forward to? These types of questions help you get a feel for what your client expects and allows you to have a dialogue to prepare them for what the big day will be like and how you typically work.
- Share stories of your experiences, good and bad.

If you find yourself in a legal predicament and you've done nothing wrong, find a good lawyer and start to settle the problem before it gets worse. Often, a lawyer can help you achieve a resolution to the problem. If you failed to provide the agreed-upon services, you must rectify your error.

STANDING YOUR GROUND

As your business grows, so does the likelihood that you'll have an issue with an employee, client, or competitor. The important thing to know is when it is appropriate for you to take legal action. First, you should try everything in your power to resolve the issue. Legal action rarely bodes well for your professional image, even if you're right.

WHEN TO GET HELP

If communication disintegrates entirely and things are escalating, you may need legal assistance. Here is a list of some scenarios in which you may choose to take action:

- The client has failed to make payment. This is particularly important when it comes to weddings, as thousands of dollars are at stake.
- You are the victim of copyright infringement (e.g., someone is using your work online or in their storefront without your permission or is passing off one of your images as their own.
- A person shoots next to you at a wedding and then claims those images are theirs or that they were the exclusive photographer for the event. If you have an exclusive photographer provision in your contract, this is a contract violation.
- An employee (current or former) uses your studio's images as advertising for themselves under their studio name, but you retain sole ownership of the images.
- A publication uses your images without crediting you.

DEFAMATION OF CHARACTER

What about defamation of character? If a past client is using social media to harass you, what do you need to bring a counter-suit?

Marybeth Priore Mantharam, Esq. advises, "You can ask your lawyer to send a Cease and Desist letter and have them take advantage of all legal and equitable remedies in your geographical location. If the past client ignores those requests and you meet the requirements of a defamation claim, you can bring a lawsuit or a counter-claim (if a lawsuit already exists)."

What if a Lawsuit Is Brought Against Me?

"Your first step should be to contact and retain a lawyer, and send them a copy of the lawsuit."

—Marybeth Priore Mantharam, Esq.

Is it Time to Take Legal Action?

"If a client refuses to pay you, infringes on your copyright, or defames your character despite your best efforts to resolve issues amicably, you should contact a lawyer and explore your legal and equitable remedies. A good lawyer can deescalate a problem before it gets out of hand and possibly help you to avoid a lawsuit altogether."

—Marybeth Priore Mantharam, Esq.

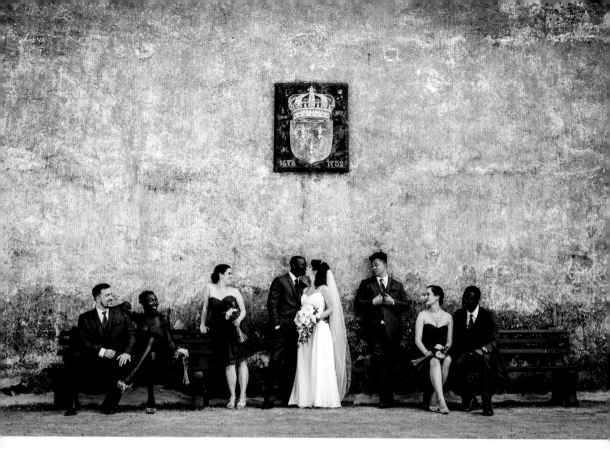

Image by Joseph Priore.

POINT OF VIEW

"Years ago, I had a customer who paid an initial deposit when the wedding was booked and one payment at six months. They had skipped the payment due at three months. The couple decided to cancel the wedding two months before the event, and the bride wanted her six-month deposit back. I told her that I could not refund it because it was too close to re-book the day. She took me to court over it. We eventually went before the judge and my lawyer had the bride read over the clause in the contract that stated 'All deposits are non-refundable due to cancellation.' The contract also specified when the payments were due. The judge threw out the case, saying that there was a clear, binding agreement for the scheduled payments. The judge actually found that the bride was liable for the three-month payment, which my lawyer counter-sued for. That's why it's so important to have a clear, signed contract. It protects you when you aren't in the wrong."

—*Joseph Priore*
www.priorephotography.com

POSTPRODUCTION & WORKFLOW

TIME IS MONEY

As digital photography continues to evolve, most people are shooting more images than ever before. The most important thing to remember in regard to your postproduction workflow is that time is money. The time spent on the final products also affects your customer's overall perception of your business. You must not lose control over your editing or let it snowball into an inexcusable return time. If your delivery time is extraordinarily slow, you will receive complaints and your business will suffer.

As you develop your business and adjust your pricing parameters, try to find a comfortable balance between the amount of time spent on each image and the price you charge. If you advertise 100 percent fully

Image by Dana Marie Goodemote.

Above—Image by Neal Urban.
Left—Image by Danielle Urban.

edited, custom images, every image you produce should receive that treatment. If your process to create them takes a long time, you must charge enough to cover the added time required to fully edit the images. In contrast, if you offer a "shoot and burn" package (e.g., mostly RAW images without editing) at a deep discount, then you can't waste time on a great deal of editing. Most people will find themselves somewhere between the two extremes. Many pros decide to offer basic color correction but refrain from extreme edits unless the client requests it as an extra service.

TURNAROUND TIME

No matter the decisions you make, ensure that you're moving along at a quick enough pace to ensure a healthy profit margin. More importantly, you'll need be sure that you are able to complete your editing work within a reasonable window of time so that clients don't have to wait too long to receive their images.

POINT OF VIEW

"Balance does not come easily for me. I feel I am always trying to achieve it. I admit, I am not a 'Type A' personality. I am creative and my brain is always going in different directions. That is why I know I must keep myself organized and focused.

When it comes to postproduction effort, I put extra focus in. It's my least favorite thing to do, and if I don't have a scheduled day for it, it's very easy to procrastinate.

I have the same day every week blocked off, and I don't plan anything else for that day. This keeps me from falling behind. When it comes to the time I spend editing, I base my prices on this equation: 1 hour shot = 1 hour postproduction. I know I want to make a certain amount per hour, so I charge my clients (X) hours times 2. This is specifically for my sitting fee (just shooting and editing). This doesn't include digital files or other products. I also use this equation to help me plan my postproduction day. For example, if I photographed three one-hour sessions that week, I know I need three hours for post."

—*Dana Marie Goodemote*
www.danamariephoto.com

Images by Neal Urban.

TIMELINESS

STAYING ON TRACK

Timeliness is one of the most crucial components of running a successful business. Not only must you respond to inquiries quickly, but you must show up on time and provide your final products within a reasonable time frame. Everything you do reflects on you personally and shapes your customers' perceptions of your business.

Your turnaround time can be as long as you want, but bear in mind the customer's point of view. They are excited to see their pictures and won't appreciate a long wait to view them. If you drag your feet, people will start to wonder what is taking so long and if you know what you are doing. They will inevitably start to compare your turnaround time to that of your competitors. It's important to remember, too, that all of the people who view the photos are potential clients. If a long wait sours your clients' impression of you and your work, they may not be as excited to share your photos with others, and you may lose prospective clients.

If you're running a high-volume studio or provide a heavily edited product, a

Image by Rachel Nichole.

longer turnaround time may be in order. If you fall into one of these categories, it is imperative that you are clear and honest with your clientele from the start about the anticipated delivery date. There must be no surprises about the completion date, or your customer will be angry.

A SNEAK PEEK

In order to appease clients who have a long wait for their images, you might consider offering a sneak peek. You could provide them with one or two images e-mailed or posted online, or a multi-image slideshow set to music. This gives them something to enjoy while they wait and keeps the excitement level high.

If your goal is to sell prints after the shoot/event, you want customers to remain excited about the experience. Unfortunately, enthusiasm fades over time, so a quick delivery is of utmost importance. People spend money when they're excited and emotionally invested in the product.

POINTS OF VIEW

"My average turnaround time is two to three weeks. I have to dedicate days to uninterrupted editing in order to keep myself on track. I turn on music, shut the door, and try not to get on Facebook."
—*Aileen Treadwell, www.aileentreadwell.com www.babydreambackdrops.com*

"I try to get ahead in the beginning of the season. I know how long wedding season is for me, and if I stay ahead from the start, I'll have more leeway later in the year when I have trouble keeping up. Eventually,

fatigue and volume will get to you, so it's important to stay ahead as long as possible. I also like to give a slightly longer timeline to my customer than what I think it will take. For weddings, I say six weeks, but I plan to have the products ready in four weeks or less if at all possible. If it is early in the season, I say it will take four weeks, but I plan to have the work finished in two. I use several wipe-off boards to stay on top of the dates and to keep an eye on how much is coming up."
—*Joseph Priore, www.priorephotography.com*

"My turnaround time is now two weeks or less for all jobs. It has focused my business. If I don't think I can get a job done in time, I outsource. So far this year, I've been able to stay on track. All weddings have been delivered in two weeks or less. I dodge and burn all of my images, but I only use one preset to give my images a consistent look."
—*Mike Allebach, www.allebachphotography.com www.brandsmasher.com*

"My average turnaround for weddings is about ninety days. To keep myself on track, I have a book in which I write down which weddings I need to finish by the end of that week."

—*Rachel Nichole www.rachelnicholephotography.com*

BUILDING A PORTFOLIO

THE IMAGES SPEAK FIRST

A photographer's portfolio is their resume. Plain and simple, it is the biggest deciding factor when a client is considering hiring you. Your portfolio carries a lot of importance, and it must reflect your style and aesthetic. It needs to show enough variety to show what you're capable of. It must speak to the client. It's imperative that it looks professional and feels well thought out. Your bio will enhance your portfolio and help round out your perceived image, but in photography, the images speak first.

As a newcomer building your portfolio or fleshing it out over the early years, you might oscillate between several aesthetics, and you'll surely make some mistakes along the way. Use your gut feeling as a guide when deciding what to include. Pick images that exemplify your perspective, not something you're trying to imitate.

Remember to show images that reflect the different services you offer. You may weight your portfolio heavily on the thing that you do the most, but if you don't show all of the different types of shoots you offer,

Image by Neal Urban.

Image by Tracy Dorr.

then you will do yourself a disservice. People can't hire you if they don't know you take portraits or do commercial shoots, for example. It's a good idea to have different albums for each type of photography in order to maintain separation.

PORTFOLIO OPTIONS

Many photographers exhibit their work mainly online, whether on a personalized website, blog, social media album, or secure image hosting website like Flickr, Smug-Mug, or Webshots. Online posting is a cost-effective option and it is easy to make updates. Your online portfolio can be as extensive as you want, and you won't incur the costs of making prints and buying albums. People can browse from their homes, at their leisure. The caveat is that you won't have anything for your clients to see and hold during an in-person consultation, and quality is often best conveyed when clients are able to see the images in person and handle high-end materials. You have total control over an album, whereas you have zero control over how people view your work online, in their home. Their monitor might be too dark or calibrated incorrectly. It might be really small. Prospective clients might even view your beautiful images on a tiny smartphone screen. Your website might not load correctly on a tablet or device.

Though digital portfolios are definitely the future, physical materials undeniably offer certain advantages.

For weddings, a demo book (i.e., a replica of an actual wedding album) often serves as a portfolio. This gives the customer a concrete idea of what it is that you offer. For corporate work, you might consider a "disposable" portfolio that you can distribute—some kind of press-printed card or book that you can leave with a potential client.

If you're intent on building a bigger photography business, it is imperative that you have a personalized website. You can use a customizable template (e.g., Squarespace, Wix, etc.) or have one professionally designed to your exact specifications. The latter option is preferable, but keep in mind that hiring a good web designer may be costly, so you'll need to work that expense into your budget. The drawbacks of using pre-made templates are that you don't have one-on-one help, the customer service is often provided solely via e-mail or chat forums, and you may not be able to customize everything to suit your tastes. Still, template-based sites are an effective and affordable way to start if you can't afford to hire a pro.

POINT OF VIEW

"My portfolio is a combination of digital and physical albums. I use digital galleries to show wedding clients a variety of images and to display photos that will relate to their wedding day. It's important for them to view albums and wall art. We are an à la carte studio, so we want our clients to fall in love with the products on display. I learned a long time ago that what you show is what you sell."

—*Dana Marie Goodemote*
www.danamariephoto.com

Helpful Hints

- Your portfolio should reflect your style and aesthetic. It must speak to the client. It's imperative that it looks professional and feels well thought out. In photography, it's the images that speak first.
- It's important that you show variety in your work. This lets prospective clients know that you have creativity and a range of experience. However, too much variety may make for a less than cohesive look that could negatively impact your brand. If your images are so varied that they oppose one another in tone, it could look like you haven't honed in on your style yet, and the viewer may wonder who you are as an artist. You want your brand to have an easily identifiable style without being a one-trick pony. Don't use the same editing style on every image, but don't go crazy re-inventing yourself in every single photograph, either.
- Remember to show the different services you offer. People can't hire you if they don't know you take portraits or produce commercial work, for example.

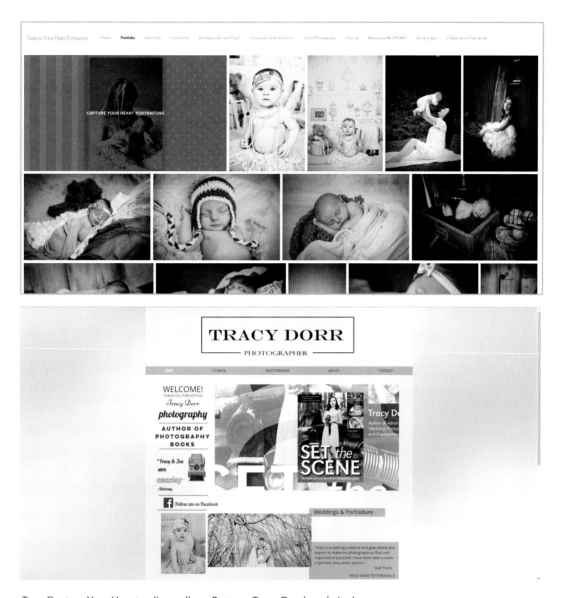

Top—Capture Your Heart online gallery. *Bottom*—Tracy Dorr's website home page.

YOUR SIGNATURE STYLE

TIME TO SHINE

Networking and staying attuned to changes in your local economy and competition will help you to shape your business model and make projections for the coming year. Being aware of what your competition offers can inspire you to set yourself apart from them. Continuously take steps to ensure your work is unique. Your personal sensibility will define the aesthetic of your photography business. Let it take its own shape and modify it as you learn and grow.

If you offer the same products as everyone else, the client will feel no urgency to book your services. Why should clients rush to book a session with you when there are one hundred of the same types of studios out there? Develop your own aesthetic and reach your customers using your custom imagery, style, and personality. When you do, you'll find that there is a demand for your work.

Your signature style is something that is built over time. The images you choose to show, the editing style you develop, a preference for close-ups or wide shots, the use of an unusual lens, a photojournalistic approach, a traditional and timeless approach, or any combination of stylistic choices will help you to build your brand.

When you have many people shooting for you, it is a bit harder to create a unified, cohesive look in your images, but it is crucial that you establish a brand so that customers know what they will get when they book your studio, no matter who shoots the session or event. When you edit your images and your staff's photos, be sure that there is a cohesive look from one job to the next. Also, be sure that a similar number of images are captured for every job and that the same basic shots are included. That way, everyone gets a similar product and knows what to expect from your company.

A COHESIVE LOOK

Your marketing materials should also have a distinctive style that is instantly recognizable and sets you apart. When shopping for marketing and portfolio materials, decide what will help define your style. It doesn't matter if you want to go modern, high end, or country chic; just be sure that every visual aspect of your business is harmonious and sends clients the same message.

MY PERSONAL EXPERIENCE

I don't think you actively define your signature style—at least, not in the beginning. It develops organically through practice; it unfolds and changes into something better, and it surprises you when it suddenly becomes quite obvious. Once you really know your signature style, you can be an

active participant in shaping it. But when you're first starting out, I don't think you can name it and make it a goal to "shoot that way." You must develop your talent first, then infuse it with your personality and your love of the craft.

ACHIEVING BALANCE

Neil Urban has some advice for finding a balance between time spent in postproduction and price:

"I have assistants who do the culling of the images and basic editing. When I started charging for my signature edits, I charged by the hour. One of those usually took me an hour. After years of practice and with better software and faster computers, I can do edits much faster, but I still charge the same. I feel that people are paying for my talent and skill, not an hourly rate. Putting in the time and investing in gear over the years is finally paying off for me."

POINTS OF VIEW

"I think it's simple: don't study the work of other photographers in order to imitate it. For the first five years, I never looked at another wedding photographer's work. I didn't want their style to influence mine. It's easy to get inspired by the work of

Helpful Hint

Your studio sets the tone for your signature aesthetic. Carefully style your room to accentuate your work and help the customer realize your vision. Here are some images of Neal and Danielle Urban's studio. Images by Neal Urban.

Previous page—Image by Aileen Treadwell. *Above*—Image by Neal Urban.

others, but that will knock you off of your own course. However, I did (and still do, to this day) study a lot of work from different genres. I looked to photographs of landscapes, architecture, fine art, and fashion. I also studied vintage films and photographs and the work of painters and illustrators. My journey started with my grandfather's World War II era camera that was handed down to me. I always wanted to create images that tell a story, with timeless portraits that paid homage to my grandfather's era. So that's why I chose to study those artists. You need to ask yourself, 'Why do I want to be a photographer? Where does the drive come from? What do you want to say with your work?' Once you figure that out, you'll slowly find your way."

—*Neal Urban, www.nealurban.com*

"I think that the best advice for creating your own brand is not to model your work after another photographer. I see so many photographers do that, and that means they are not unique. Embrace what you love! If you love color, don't tone down your images because someone else does. Be true to what you love. No one can shoot like you!"

—*Rachel Nichole*
www.rachelnicholephotography.com

"My advice is to decide what you want to do first. To create art, one follows their own personal style and only their ideas. Innovation is very important when it comes to creating a signature brand."

—*Annie Mitova, www.anniemitova.com*

TAXES

DEDUCTIONS

Taxes are more complicated when you run your own business. Stay up to date on changes to the laws and hire a good accountant to help you stay on top of everything. You must save all receipts pertaining to write-offs and deductions. Also, be sure to save any 1099-MISC or W-2 forms you receive.

 Here's a list of some common tax deductions:

- books, magazines, reference material
- continuing education classes or seminars
- business insurance
- cab, subway, and bus fares (if you are traveling on business, of course)
- equipment (camera bodies, lenses, bags, batteries, flashes, etc.)
- film developing/processing
- prints, canvases, cards, and books
- marketing materials
- advertising fees
- film or digital supplies (like CF or SD cards)
- gas and electric for your studio
- Internet service/website fees
- legal and professional fees related to your business
- memberships to professional organizations

Image by Tracy Dorr.

- messengers, private mail carriers, postage
- mortgage interest/taxes if you own a building used for your business; if you have a home office, you can deduct a portion of your costs
- office supplies (paper, ink, etc.)
- props used for photos
- backdrops, stands, and other studio equipment
- photo software
- staff fees
- studio rent
- studio supplies
- stylists/makeup artists' fees
- tax preparation
- telephone
- travel

GRAY AREAS

Some things are deductible only in specific circumstances. For instance, business meals and entertainment are acceptable write-offs only when used to attract a potential client or entertain an existing one. You need to note whom you entertained and for what purpose. Clothing is another gray area. You can write it off if your business logo appears on it, but you can't write off generic clothing that you wear every day. Travel expenses for a job or photography conference can be used as a write-off, but general vacation expenses cannot.

DON'T FORGET ...

Mileage is a deduction you won't want to forgo. Keep track of the number of miles you drive to meet with a potential client or to get to a job site. You must keep a log of where you went, the date and the purpose of travel, and the number of miles driven. You can purchase a digital mile tracker that will do it all for you, or as CPA Jeffrey Schlabach (president of Schlabach Enterprises, Inc.) recommends, try a smartphone app. He says, "It's best to e-mail the log to yourself or print it out periodically so you have a backup in case you get audited. Most new businesses neglect this area of their business, and it hurts them down the road."

HELPFUL HINTS

- Develop a system of saving receipts and bookkeeping. You might opt to utilize a program like Excel or QuickBooks or one that is designed for photography. Good bookkeeping ensures that you will stay on top of things and alleviates fears of being audited. It helps you keep track of income and spending and can help you to set goals for the coming season.
- Pay your sales tax on time to avoid penalties.
- Pay your quarterly taxes in order to avoid one huge payment at the end of the year. Check with a professional to determine what is required, as this varies depending on the business class.
- If you decide to hire employees, note that: (1) If they make more than $600.00, you must report their income. (2) If they are a contractor providing a service to you, then you must send them a 1099 at the end of the year. (3) If they work for you in your studio, you must provide them with a W-2 and (4) Once you start providing W-2s, you must also pay an employee tax and pay into Worker's Comp.

- There are a number of tax mistakes commonly made by photographers. These include not collecting state sales tax, not saving receipts, forgetting about self-employment tax, improperly writing off home office rent (only the portion of your home that is used as an office may be written off), and using the E-Z form and neglecting the potential deductions you may be able to take.

NOTES FROM A TAX PRO

Tax issues plague many photographers. Jeffrey Schlabach, president of Schlabach Enterprises, Inc., offers some tips for easing the burden:

- When you hire a professional, you are assured that everything is being done correctly and legally. You have an experienced person reviewing the return before submission, which should greatly reduce the probability of being audited. Tax laws are constantly changing and evolving. There are certain limitations on deductions, and other tax attributes can change from year to year. You are apt to miss them if you are not a tax professional. Make sure you hire an accountant or tax professional who is certified and who takes a great deal of continuing education courses. Feel free to ask for qualifications.
- When clients try to prepare their taxes by themselves using an online tax software program, they often put numbers in the wrong boxes and improperly state things on their return. They end up needing to have the return amended by a profes-

sional and/or have to respond to the IRS notices on the returns once the returns are reviewed by the IRS, many months after submission.

- Accounting and tax preparation fees vary greatly, depending on the scope of the work performed (e.g., a close review of your income and expenses costs more than simple data entry). Many tax preparers who are not CPAs, enrolled agents, or don't have an accounting degree don't understand the rules of general accounting principles and are typically just entering data into their software. This works for basic returns and simple tax situations. However, when things get complicated (especially in business), things can sometimes go awry.
- I always advise people to ask for their tax preparer's experience, qualifications, and certifications. I would never feel annoyed if someone took the time to interview me and find out about my skill set. They want to determine if I am as qualified as I present myself to be. That being said, you get what you pay for. Be skeptical of accountants or tax preparers who advertise based on low-cost preparation. They generally don't have the education or certifications to do anything above and beyond simple returns, which are their bread and butter. Sometimes they even attempt work outside their scope of knowledge and can get clients in trouble quickly.

BUSINESS CLASSIFICATIONS

If you're not sure what type of business class would best benefit you, talk to your tax accountant or tax attorney for advice. The information in this section is intended only as an overview of the various options.

DBA ("DOING BUSINESS AS")

Sometimes it makes sense for a company to do business under a different name. When this is the case, the company has to register as a DBA. Once your DBA registration is complete, you can use the secondary name to open bank accounts, write checks, and enter contracts. If you don't file a DBA and begin doing business under a different name, you could face penalties, fines, and lawsuits.

Sole proprietorships commonly use DBAs because a sole proprietorship's official, legal name is simply the name of the owner. A DBA lets them use a real business name. However, LLCs, corporations, and partnerships can all file to get a DBA.

SOLE PROPRIETORSHIP

This is the simplest type of business. There is no legal distinction between you and your business. You are in direct control of

Image by Tracy Dorr.

everything, and you are legally accountable for everything.

PARTNERSHIPS

If you decide to split everything between you and an associate, you'll register as a partnership. In this case, all profits and losses are shared proportionately and you are both legally responsible. Both parties sign a written partnership agreement and file a certificate or registration of partnership with the Secretary of State office. You also need to obtain business licenses and permits—federal, state, and local. It's good to consult an attorney, particularly with your written partnership agreement.

There are three types of partnerships: general, limited, and limited liability (LLP). General partners share equal rights and responsibilities, as defined above. Limited partnerships allow each partner to restrict the amount of their involvement, but at least one person must be fully liable for the business' debts and obligations. An LLP

retains the tax advantages of the general partnership but offers some personal liability protection to the participants. Individuals are not personally responsible for the acts of the other partners.

CORPORATIONS

A corporation exists as a separate entity. It keeps a legal divide between you and your business, so you're not personally liable and your assets are safe. You'll file articles of incorporation with the appropriate agency in your state. After incorporation, stock is issued to the company's shareholders in exchange for cash or other assets. There are three types of corporation: general, S-corp., or close corporation.

An S-corp. is a special tax designation applied for and granted by the IRS to corporations that are already formed. This is beneficial to small-business owners because it combines many advantages of a sole proprietorship, partnership, and the corporate forms of business structure. Special tax provisions include avoiding double taxation at both the personal and corporate levels because income and loss is only reported once. In a general corporation, you pay federal tax on your income and shareholders also pay tax on their own personal income.

NETWORKING

CONNECTING WITH OTHER VENDORS

Networking is important on several fronts. You want to establish good rapport with vendors of all varieties (DJs, limo companies, bakeries, florists, etc.), but it is also beneficial for you to maintain an amicable relationship with your competition.

Establishing a great relationship (or exclusive referral system) allows you to direct customers to one another. From a sales perspective, customers appreciate hearing that you work well with other vendors. It assures them that you have a friendly and consistent personality. It is particularly important in the wedding business, since clients have already put their trust in you. They want to know who you trust so they know where to shop next.

For instance, by establishing a relationship with a reception hall, the venue knows that you're a solid, professional choice and that benefits them in two ways: they know that you will act professionally on the day of the event and communicate with them. They also know that you will be willing to send them great images afterward at no cost, which will help them sell their services to potential clients. Obviously, you benefit from the booking, so it is in your best interest to provide them with printed or digital

Image by Dana Marie Goodemote.

Above—Image by Joseph Priore. *Following page*—Image by Dana Maria Goodemote.

images and/or a book showcasing their venue to its highest potential.

Commercial work often leads to future jobs. For example, a simple business portrait could lead to an opportunity to take photos of the entire company and of their building(s) for their website. Later, an architectural associate may ask for your name for himself and a fellow developer. If they are happy with your work, you will find more jobs. They may invite you to parties or social functions where you get to meet more potential clients. In real estate photography, making friends with one agent can lead to the opportunity to take head shots, and photographs of residential or commercial building interiors and exteriors.

NETWORKING WITH YOUR COMPETITION

It is also a good idea to network with your competition. This way, you can refer clients to your competition, and they can reciprocate. This is of utmost importance when you find yourself in an emergency situation. If you can't fulfill your contract because of a health issue or a death in the family, you'll need to turn to people you can trust.

Networking can also lead to a great partnership or the addition of a great second shooter.

Take advantage of all of the networking opportunities in your area, from online forums to bridal association gatherings.

Helpful Hint

Setting up a reciprocal referral system with other vendors is a win-win. It helps you to build your reputation over the years, it provides free advertising, and helps give prospective customers peace of mind. Working with like-minded businesses helps the day go smoothly because you understand each other, look out for one another, and offer a similar style.

POINTS OF VIEW

"When you're in a referral-based business, you want as many people talking about you as possible. Networking establishes good relationships with people I work with regularly and creates referrals. It makes my business stronger when a bride hears about me from a DJ and also a manager at a banquet facility. Networking gets your name out there more, and when your name keeps popping up, it looks good to a prospective bride and gives her confidence in you. Plus, when you work with people you know, things go more smoothly."

—*Joseph Priore, www.priorephotography.com*

"I occasionally use print advertising, but I do not find it to be particularly effective. For me, to put advertising dollars toward a print ad in a magazine or other publica-

tion, the audience has to be very specific. I do use Facebook. I find that our Facebook page brings us qualified clients. For weddings, I find bridal shows to be effective. I am a people person, and I find that people connect best with me when we meet in person."

—*Dana Marie Goodemote*
www.danamariephoto.com

"Networking for me is very important because other studios become a source of new business if they cannot accept the date for any reason—and vice-versa. I've been in the wedding business for over forty years. I've found that most studios will help out others if they can't service the customer calling."

—*Frank Priore, www.priorephotography.com*

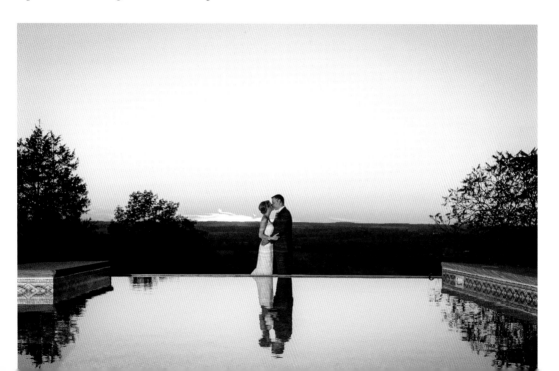

ADVERTISING

PLANNING

Advertising has changed a lot over the years, and there are varying opinions as to the best approach. You have to determine how much you want to (or can afford to) spend, how you want to spend it, and who will design your ad. It all comes down to what will bring you the best return on your investment, and that can only be discovered through experience.

Begin by researching the best places to advertise by reviewing local publications and

asking the people whom you are networking with what they think. Some companies provide a list of prospective clients' names and numbers so that you can make contact. Marketing companies can provide you with that type of information for a fee. Facebook allows you to customize your ad and target the right people, and you can determine what you want to spend per day.

While a lot of money is being spent in online ads, print ads target a different customer base. You will need to determine what you are most comfortable with and what budget makes the most sense.

Your ads will help you develop your brand. Make sure that the style and design of every ad reflects and reinforces what you want to say about your company. An ad designed to target high-end clients should be clean, simple, refined, and timeless. A country-themed design will show that you can provide images with shabby-chic wedding aesthetic. Advertise with fun, happy images to show that you're all about enjoying the wedding day. If you want to appeal to a wider demographic, don't pick anything too specific. If you want to be known as a one-of-a-kind artist, your ads should be dramatically different than anything you have seen elsewhere. Keep in mind that the design you choose makes a statement to the customer you hope to attract. The mood

Image by Joseph Priore.

conveyed in your materials will quietly influence the prospective customer's decision before they even look at your prices.

A RECIPE FOR SUCCESS

Always keep track of how people find you so you know which advertising approaches are working for you. If you seek only a limited number of weddings or jobs per year, you may not need to advertise much; word of mouth may sustain you. If you find out that most of your jobs are coming from personal referrals, you can reduce your advertising budget.

POINTS OF VIEW

"In the past nine years, I haven't paid for advertising. Sure, I purchased business cards, but I hardly give them out. I let word-of-mouth advertising from happy customers bring in new clients."

—*Neal Urban, www.nealurban.com*

"I have tried many forms of advertising. I feel that it's very important because it lets people see your name over and over again. The more often they see your company, the more confident they feel that you are a leading name. When their friends mention you too, they've heard about you from multiple places and are even more interested. Word-of-mouth is made stronger by your advertising."

—*Joseph Priore, www.priorephotography.com*

Image by Tracy Dorr.

Helpful Hint

Advertise to help your clients find you easily. Note that the type of advertising that works best will be different for each type of photography business and each type of client.

MARKETING

THE GOODS

Advertising can also be accomplished via certain marketing materials. Pens, calendars, handouts, and brochures all remind people about your business.

Physical items like pens and magnets (which people want to keep) cleverly put your phone number within easy reach. While advertising gets your name and number out in public, marketing is really about establishing your brand. It includes everything that you produce, which defines your business' style.

KNOW YOUR BRAND

Mike Allebach is a leader in marketing education. He runs the website Brandsmasher .com, which provides photographers with marketing tips and advice from the pros. His advice? In order to figure out how to market yourself, know your individual brand. That's your platform. Develop that and grow. Allebach says, "Ask five to ten friends to identify your quirks and your strengths. Build your business and brand on those. This is probably the most effective exercise in developing a brand I've ever

Image by Aileen Treadwell.

recommended. Everyone who has completed this exercise has seen their business grow. We are bad judges of our own strengths. Once other people recognize our strengths, they can form the core of our business."

Once you've identified your strengths and have begun the process of creating a solid brand, you need to figure out what marketing options are available to you, what you can afford, and what makes good common sense in targeting the customers you're hoping for. Don't waste time targeting the wrong customers. You'll leave each other frustrated, and they won't return in the future anyway.

There are many ways to market your business. Here are some things to consider:

- Give away pens, candy, brochures, etc., with your logo and contact information on them.
- Ensure that your company logo is on your bags, folders, CDs, USBs, DVDs and cases, etc.
- Use social media to share images.
- Run online contests to develop interest in your brand, and offer prizes for clients who share your link.
- Use cohesive branding that extends from your website to your promotional materials and the decor of your studio.

Marketing is one of the most personal choices you'll make in this business. There are endless ways and combinations of ways to market your services. It can be overwhelming at first, so listen to those who have come before you in order to forge your own path.

POINTS OF VIEW

"The best marketing plan makes your clients happy and pushes them toward reviewing you and talking about you. If you can't deliver on customer service, don't spend another minute on any other marketing effort. Customer service is the most important part of any marketing plan. Over-deliver. Give a little extra. Accidentally include an extra print, an extra page, or something special in every order. Throw candy or a personalized present in mailings."

—*Mike Allebach*
www.allebachphotography.com
www.brandsmasher.com

"I hate to say it, but I think bridal shows might be a mistake for beginners. Once you build up your portfolio, you can give it a shot. Some businesses do have it down to a science after many years of experience and are very successful, which is great. Those are usually the studios with multiple photographers working for them, and they need the volume. If you're starting out as a sole photographer, you probably won't be able to compete with those established businesses. Before doing a bridal show, be sure that those brides are your target market. I recommend getting out there and building relationships. Make friendships with other vendors, including other photographers, and use social media to your advantage. Everyone is very accessible these days. If you're a likable, professional person, then referrals will pour in."

—*Neal Urban, www.nealurban.com*

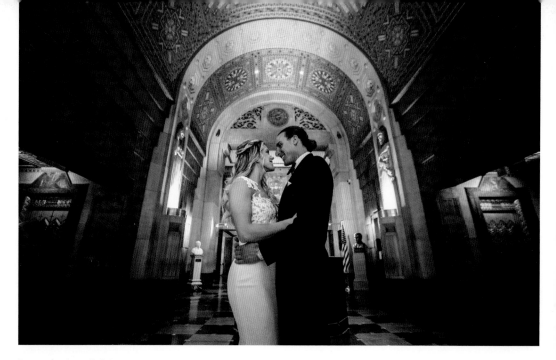

Image by Joseph Priore.

"I feel bridal shows are extremely important. You're going to meet a wide variety of customers there. Sure, some of them are just price shopping, but others have already researched you online or heard about you some other way, and they are eager to meet you in person and see your booth. Most people want to gather information, sit and talk about it at home, and browse your online portfolio. I give out hundreds of brochures. I don't make it a goal to book a bunch of brides at the show, but rather to get my information in their hands so they can go to my website after they get home. That's where you need to hook them. I think it takes more work than simply booking on the spot because you are capturing lifetime memories. That's a big decision for the customer, and they want the time to think it over at home. Don't go into a bridal show expecting a lot on the spot, or you'll fail.

Bridal shows are worth it for big or small studios because you're getting access to hundreds of brides in one day. You're getting your information in their hands and giving them a face to go with the name— and they can see that you're established.

After the shows, I often hear, 'Oh I saw you at the bridal show, but you also shot my friend's wedding.' This is great because your reputation has been vouched for through two different channels."

—*Joseph Priore, www.priorephotography.com*

"The biggest mistake you can make when you're first starting out is to go into debt. I have always had the cash on hand when I have purchased equipment. Rent or borrow, but don't go into debt. That way, if things don't work out, you won't be stuck paying off bad debt down the road."

—*Drew Zinck, www.drewzinckphotography.com*

CREATING LIFETIME CLIENTS

GENERATE HAPPINESS

Your business will grow year after year as you establish personal relationships with your customers. You want them to think of you first and leave happy to return every time. This is of particular importance for portraiture, where your photographs will continue to evolve as the family grows and changes. If your clients are thrilled with their wedding images, they will return for maternity and newborn shoots and keep coming back for years as their family grows.

Make your clients feel as comfortable as possible at all times. Encourage their return with friendly reminders or discounts on yearly packages. Brainstorm ways to personalize your products at each shoot. Remember all of their children's names and the correct spelling of their names, and maintain a kid-friendly facility so that they are entertained during down time.

SMILE

Photographer Rachel Nichole has a simple, smart piece of advice: "I can't recommend smiling enough. When you are pleasant and friendly, your clients relax and warm up to you. Being personable is very important. If a client doesn't like you, it won't matter how great an image you take."

This is a fundamental point. Keeping your customers not just happy, but happy

Images by Joseph Priore.

to return, is key. Don't overlook the human side of photography.

POINTS OF VIEW

"To make my clients feel comfortable, I always tell them how great they look. I

even show them the images so they can see how good they are turning out. I joke and laugh with them. I also see if they have any ideas they would like to incorporate into the shoot."

—*Rachel Nichole*
www.rachelnicholephotography.com

"I follow clients on Facebook and always comment on their kids' pictures—the regular pictures they take with their phone. It's all about maintaining a relationship and caring about them. I send out e-mails when I have mini sessions coming up, and I always try to wish my clients and their kids a happy birthday."

—*Aileen Treadwell, www.aileentreadwell.com*
www.babydreambackdrops.com

"As you build relationships with your customers, you will find that you get new accounts through those who were happy with you. They will think of you again when they need someone for a different job. Shooting a wedding can lead to portraits and to corporate work for someone's business. For example, I built a relationship with a bride that led to a relationship with her family. That led to her mom thinking of me and referring me to the University at Buffalo's Pharmacy department, which is an account I've now maintained for more than ten years."

—*Joseph Priore, www.priorephotography.com*

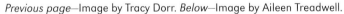

Previous page—Image by Tracy Dorr. *Below*—Image by Aileen Treadwell.

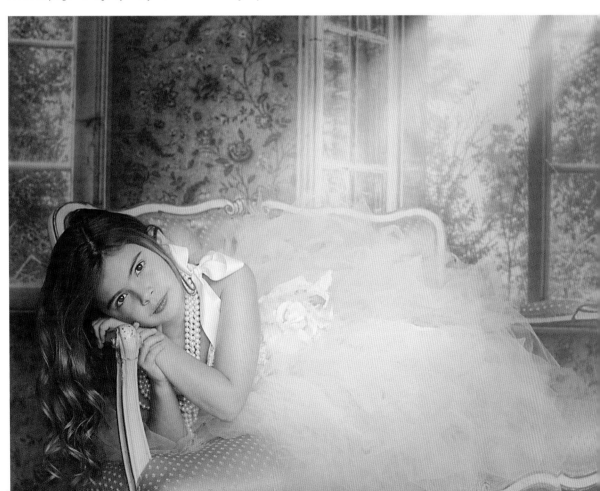

WORD-OF-MOUTH REFERRALS

THE BEST FORM OF ADVERTISING

Referrals are, hands down, the best form of advertising. You can advertise like crazy and see some results, but if people aren't saying good things about you and your work, your business will falter. The one thing that keeps customers coming back for more is solid recommendations.

This kind of referral results from an intimate source—parents, friends, or coworkers—so it naturally inspires trust. Before prospective clients even meet you, they have a good feeling about the appointment. No paid advertisement can replicate that feeling of trust. The quality of your work and a welcoming personality will cement their favorable impressions. Do your best with every client to satisfy them and keep the referrals coming. You can even increase the odds that your customers will spread the word about your services by offering friends and family discounts, referral credits, or thank-you gifts.

POINTS OF VIEW

"Focus on social media and building relationships. Try to book a minimum number of sessions per month and focus on making

Image by Aileen Treadwell.

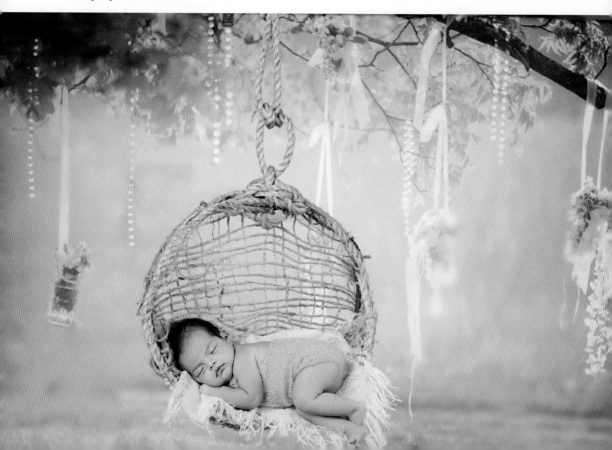

Image by Tracy Dorr.

those sessions as amazing as possible so that your clients will go tell their friends about the experience. The referrals should just snowball. The key is having a relationship with your customers because they are the ones who will tell their friends and post about you on social media sites."
—*Aileen Treadwell, www.aileentreadwell.com*
www.babydreambackdrops.com

"My clients know they are encouraged to be themselves, to push the envelope, and to be creative. Ultimately, people know I'm accepting. I've even had headshot clients approach me and say, 'I selected you because of what you said on your About page. I love that you are so inclusive.'"
—*Mike Allebach, www.brandsmasher.com*

"In order to keep people returning, I try to make sure they enjoy their sessions, and I get their images to them on time. I always listen to what my clients want."
—*Rachel Nichole*
www.rachelnicholephotography.com

SOCIAL MEDIA NETWORKING

A POWERFUL TOOL

The social media explosion was inevitable, and it has made its mark on the way photographers advertise and market. Most photographers will engage on social media sites in some capacity, and many pros swear by the benefits of these sites, as well as running advertisements on them. The main advantage is that social networking sites are common forums: people visit there daily—they don't have to search for your website specifically. They can also function in place of a blog with your daily updates.

Everything you do is aimed to get people to "like" and follow your page. Make posts interesting by utilizing sneak peeks of your client's portraits or sharing your favorite image of the day. Testimonials by happy customers can go a long way toward enhancing your reputation. Social media sites are an easy and familiar place for people to leave their comments, so it's important that you embrace the format.

Facebook is hugely popular, and so you may find that you have the potential to reach the most people through networking on that site. When you share images and information with your existing clients, you also reach their friends and family without relying on the customer to talk to them in person. It takes the place of word-of-mouth advertising and fills it visually with your images.

Aileen Treadwell is a proponent of networking on social media sites like Facebook because she feels you can use them to exponentially and easily boost word-of-mouth referrals. It's the perfect platform to let people share images and spread the word about your business, which is the ideal kind of advertising. The sites let you connect

Left—Image by Aileen Treadwell.
Following page—Image by Tracy Dorr.

easily with your customers on a personal level, and it is easy to advertise and create the constraints and budget you want to use.

THE DRAWBACKS

On the other hand, there are drawbacks and limitations to using social media sites to promote your photography businesses: (1) It may lessen the traffic to your website. Your page is like a light version of your portfolio and it is less customizable than a website. (2) It's not a custom service, which can leave you frustrated. Certain settings may not coincide with your personal preferences and can't be changed—you're limited to the format provided. (3) If customers aren't daily social media users, they will of-ten miss your updates. (Plus they need to be following your page for updates. Not everyone will take the time to follow your page.) If you post updates too often, you run the risk of being annoying, and people will stop following you. They also may not take the time to go to your Facebook home page and browse, beyond the updates that they scroll quickly past. (4) The added daily time commitment to maintain your presence on these sites is significant. When you are very busy and feel overworked, it may seem like a real hassle to tend to your page.

POINTS OF VIEW

"Facebook helped my business to boom. It can be an amazing tool. It helps you keep relationships going without bugging your clients with e-mails or phone calls. Plus when you tag them in all their photos all of their 'friends' see the picture, which creates instant exposure."
—*Aileen Treadwell, www.aileentreadwell.com www.babydreambackdrops.com*

"It's very important to post to Facebook. About 85 percent of my business comes from there, and I try to post a lot! The more of your work a client sees, the more they share with their friends, and the more clients you book. Facebook and Instagram are both amazing tools to use."
—*Rachel Nichole www.rachelnicholephotography.com*

"It's important to share on social media, but Facebook is not the only online social media available to photographers. Although it is currently the most popular social media

Image by Tracy Dorr.

Image by Tracy Dorr.

network, the restrictions on pages prevents an organic reach on posts."

—*Annie Mitova, www.anniemitova.com*

"Use social media only if you're going to commit to it, and use just a few outlets. Do not try to do Facebook, Twitter, Snap-Chat, Instagram, Tumbler, etc. Pick one to three options. Don't do it halfway; commit yourself to posting. Only doing it once in a while will not create positive results."

—*Drew Zinck, www.drewzinckphotography.com*

"Things are easier now with all of the social media platforms available to photog-

raphers. I might sound like an old man, but 'back in my day' the only social media I had was MySpace. After that died a quick death, I had to start over with Facebook. I was lucky that a lot of my customers were loyal and found me again. The same was true of Instagram, Twitter, Google+, etc. Back then, MySpace required a lot of time coding, which took time away from running my business. Now, within minutes, you can set up a page and share your work. And the best part of it all? It's free!"

—*Neal Urban, www.nealurban.com*

CONTINUED GROWTH

MOVING AHEAD

Continued growth is critical to achieve business success. Building client relationships that inspire trust and lead to referrals, networking to attract new clients, and utilizing smart advertising and marketing approaches that get you noticed will help you to move in the right direction.

VARIETY IS KEY

Another point worth mentioning is that the creative choices you make can inspire

your clients to return. In studio portraiture, the variety you offer comes from your backdrops and props. The more you have to offer (and the frequency with which you update your offerings) keeps customers returning. A person wouldn't be likely to return year after year for the exact same set. They're naturally going to want to do something new every time. If you offer two or three sets in one shoot, or four to five shoots per year, that variety can be difficult to achieve, but it's important to keep refreshing your options in order to give people a reason to return. They already love your personality and the quality of your imagery. Now back it up with fresh, new ideas to inspire them.

POINTS OF VIEW

"I think it's important to include nothing in your packages but time and talent. Our packages are the wedding day shoot only. We charge a lot for our services, so if clients don't purchase many prints or albums after the fact, we're covered. We don't need to rely on those sales. But over the years, we have grown confident in the prints and albums we display in our studio. I feel that once customers see them in person and feel the quality, it's a no-brainer to make a purchase.

Left—Image by Tracy Dorr. *Following page*—Image by Neal Urban.

We also offer add-on shoots to up-sell. Engagement portraits, bridal portraits, boudoir sessions, and post-bridal (i.e., trash the dress) sessions all add to our income. You can also make more money from guest books, save-the-date cards, thank-you cards, and albums for boudoir portraits, for example."

—*Neal Urban, www.nealurban.com*

"There are so many great ways you can up-sell your packages! For example, if you offer pre-made packages for your services and/or products, offer add-ons that are fun and unique. Market them in a way that makes it impossible for your client to say no. Most purchases are an emotional buy; use that to your advantage. Offer add-ons at the order session. At that time, clients should have already paid in full. If you offer them two or three add-on options and make them available only at that time, you increase the likelihood of a sale. I don't offer those add-ons later.

Another great way to up-sell your work is to sell à la carte products. Instead of packaging your services and products together, price everything separately. That gives you room to charge a higher price per product."

—*Dana Marie Goodemote*
www.danamariephoto.com

"Remember that the relationship you build with your wedding clients can last beyond that one event. After they're married and get pregnant, you want them to have you photograph their family. You want to capture all of the important family events through the years.

Image by Dana Marie Goodemote.

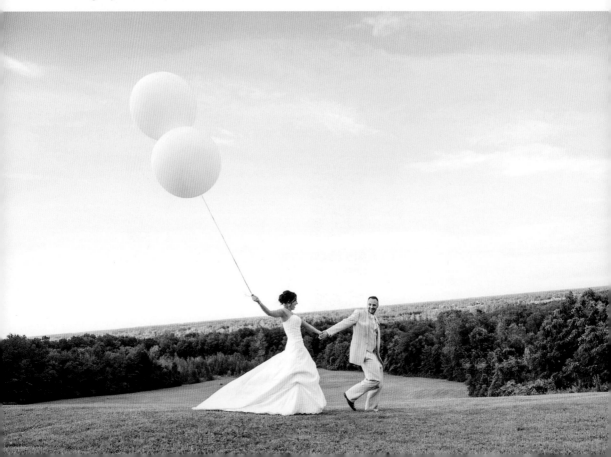

First, make sure your marketing reflects that you're not solely a wedding photographer. When the client's wedding pictures are done, include a little gift card or a flier or something that serves as a reminder that they can call you for their other photo needs. Always work to maintain the relationship."

—*Joseph Priore*
www.priorephotography.com

"During an appointment, I laugh and talk nonstop. I always ask questions about the client's life and their world. It helps them open up and feel like they want to get to know me. I always try to hug them and thank them when they leave. This creates a bond."

—*Aileen Treadwell*
www.aileentreadwell.com
www.babydreambackdrops.com

Images by Aileen Treadwell.

A CHANGING INDUSTRY

Your passion for creating beautiful pictures brought you to this point, as it has for thousands of other like-minded individuals. The urge to work in this field is also fueled by a constant change in technology. As digital cameras, editing software, and computers increase in quality and diminish in price, the dream to start your own photography business has never been more attainable. Of course, that also means that the competition is growing exponentially. This is an important fact to be aware of, as it affects all photographers.

It is important to assess your competition as you start out on your journey. Is the market over-saturated? Is there room for you? Is your aesthetic unique? If so, how? Be cautious and evaluate how many photographers there are (and what services they offer) as you define your goals, both in terms of how many clients you hope to book and how much money you aspire to make. It's important to know how many clients the photographers in your area draw in order to make an educated guess as to what you can expect.

Image by Joseph Priore.

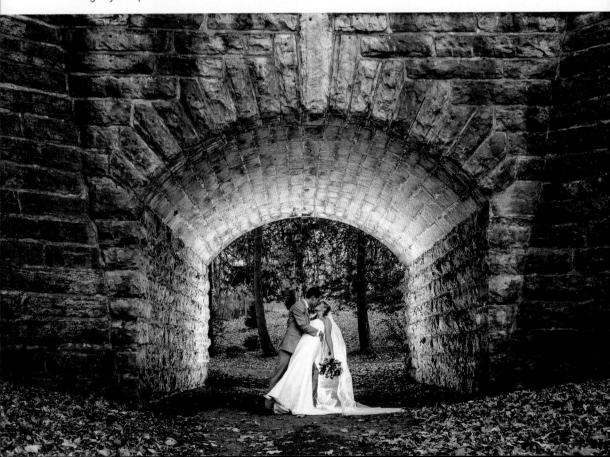

Image by Tracy Dorr.

If you're concerned that there are too many photographers in your area who are competing for the same clients, you might consider forming a partnership with another shooter or teaming up with a large studio that employs several photographers. Doing so can also spur you to develop a product that no one else offers, through collaborative creativity.

Remember, we were all there once! Every successful photographer started where you are now. Don't come in unprepared and undercut everyone or offer an unprofessional product. Join the rest of us and learn the trade from a professional. Education is your friend.

MY PERSONAL EXPERIENCE

The way the industry is changing is complex and constantly evolving. Now there are an amazing number of opportunities available that you can take advantage of to realize your photography dreams. You aren't bound by traditional approaches anymore. It is affordable to start a business, and you have an incredible amount of personal choice in every aspect. If you're passionate about taking pictures and you want to make photography your life, you can do it!

I also believe it's important to offer the highest-quality images and to have years of experience before you label yourself a professional. Put in time to learn before you open a business. If you don't take the

Image by Tracy Dorr.

necessary steps to educate yourself and get quality training, you risk producing a sub-par product that will leave your customers unhappy. The respect that you have for the craft while putting in hours of training generates great photographs. That continues even after you are established. The temptation is strong to drop prices and cut corners to compete, but the more we do that, the more we're all hurt. I don't believe that we can withstand that for long. We shouldn't be moving backward, but forward, together.

POINTS OF VIEW

"I think you should worry about yourself first and foremost. But you do need to be aware of what your competition is up to. Looking at what else is out there helps

you to figure out where your price bracket is and where you belong in the market, without undercutting the industry. It helps you define what makes you different from everyone else. If you are too similar, consider making changes."

—*Joseph Priore, www.priorephotography.com*

"I believe that receiving a quality education is extremely important, no matter the field you pursue. You can't become great at something without the fundamental building blocks.

I started my career at the age of seventeen working as an apprentice for a photographer in my hometown. I then went on to college and majored in photography. After graduation, I worked full time for a

commercial photography studio and part time for a wedding photography studio. I worked for both studios for four years before I opened my business.

In the photography world, there are many ways to receive a quality education. You can go the more traditional route and attend a university. You can become an apprentice and work for an established photographer. Or, you can teach yourself. All of these options will aid you in the pursuit of your dream. I do feel that it's important to study with another professional before going out on your own. Seeing the inner workings of an established studio is helpful. Training to become a professional photographer should be no different than putting in the training time for any other type of professional position."

—*Dana Marie Goodemote*
www.danamariephoto.com

"Photography has changed a lot since 1975. At one time, the pro photographer had to understand the mechanics of so much, and equipment problems were prevalent. Now, thanks to digital photography, there are tons of photographers. Remember that true photography is made not in a computer, but in the photographer's brain."

—*Frank Priore*
www.priorephotography.com

"I was once told 'There is no such thing as a bad business, just bad business people.' The same holds true for modern photography. If you compete based only on price (and the cost of entry is now low, so your price could be very low), then you're likely to go out of business. You need to be able to sell value. Bring that to whatever subject you're photographing. Experience, style, connections, and knowledge all add to your value as well."

—*Drew Zinck, www.drewzinckphotography.com*

Images by Neal Urban.

Image by Aileen Treadwell.

"To be honest, it's getting tough out there! When I started nine years ago, there were only twenty or thirty photographers in my area. Now there are well over 500! I see so many talented photographers come and go because they are failing at the business side of things. They get a rude awakening when they realize that taking photos is only 10 percent of the job.

If you want to be a successful photographer, you have to be a smart business owner. Learning to run a business is prob-ably the most important thing. Before I became a full-time photographer, my day job was in retail, where I worked my way up to assistant manager of a successful company. I knew how to run a store, manage a staff, schedule, and provide good customer service. I knew about keeping books and keeping a balanced cash register. I learned all of the things that are helpful, and I learned what not to do. I also learned how to treat the team and customers. During those years, I attended college programs

and took courses in entrepreneurship, economics, marketing, design, painting, logic, and psychology. Those things come into play every day in my business. Be patient, smart, and strong. If you hit it right, buckle up! It's a heck of a ride!"

—*Neal Urban, www.nealurban.com*

"The photography business has been through some big changes over the past ten years. With the digital age and low cost of cameras, the influx of new photographers is always on the rise. When I started, film was the medium of choice and photographers were getting paid for their work. There was no such thing as purchasing the film from your shoot and printing it on your own. Photographers sold prints, not images.

Back then, there was a standard system amongst professional photographers. When the digital age arrived, we took a hit. Beautiful, profitable prints were replaced by digital files. Including digital files with your services has now become common practice and something clients expect. I often hear from other professionals that they aren't making enough money and that there's too much competition.

I agree that there's a decent amount of competition, but I feel that competition is a healthy component of any industry. The way I see it, you can be the best photographer in the world, but if you don't have good business sense, you will not survive. I am a photographer, but I am a business owner first.

The photography world is no different than any other industry. You need a strong business model and a plan to succeed. In my opinion, a first-time photographer should educate themselves as much as possible, particularly on how to run a business, before jumping into the market. There will always be competition, and there will always be businesses that thrive and fail. It's important to position yourself to thrive."

—*Dana Marie Goodemote*
www.danamariephoto.com

"I've been in this business for twenty-one years. I've never seen as much competition as there is now. Today's cameras are very affordable, and anyone who is interested in photography can start a new business without breaking the bank. I think the important thing to remember is that you have your own unique qualities.

I was once where you are. I understand how hard it is to get going. I found it helpful to work for someone else for a while to gain knowledge about the industry and get experience while perfecting my craft. When I was ready to go out on my own, I fulfilled all of my commitments and made myself available to the studio for a year. I did it in a way that we could continue our relationship with no hard feelings. You don't want to put someone in a bind.

The biggest thing I see now is the pricing gap. It's important not to come out and undercut the local industry. Even though you should start out at a lower price range, make sure your prices are not so low that everyone else is forced to drop their prices to compete. Doing that moves us all in the wrong direction."

—*Joseph Priore, www.priorephotography.com*

CONCLUSION

It has never been more affordable to break into the photography world, but the truth is, you face many complicated choices as you begin your journey. If you want to climb the ladder and make the transition from amateur to professional, it's important to have a clear understanding of all that goes into this business. A hobby is fueled by love; a business is fueled by a blend of talent, economics, personality, experience, and luck.

When you take photos for yourself, it is a simple and beautiful act of creation, and it is thoroughly enjoyable. When you photograph for other people and for money, your love of the craft may be overshadowed by the realities of running your own business. Make the move only if it is the right fit for you and if you have a clear vision of what you want to achieve.

Many photography topics are subjective and personal to the artist, as are the stylistic choices we make while shooting and in editing, the aesthetic tone we set in branding, and even the way we choose to spend money and interact with our clients. Most

Image by Tracy Dorr.

Image by Tracy Dorr.

decisions will come down to a personal choice, backed by experience.

Open your mind to advice you receive from seasoned professionals. It can dramatically impact your decisions as you face your business options and can even help you to enhance the artistic side of your craft. Those who have come before you have a wide range of opinions, and it is precisely those differences that create the individual atmosphere of each business. Use the conversations and insights in this book to help you move forward in your journey and form your own vision.

You are blessed to have a talent you can share and build a business around. This is a fun and rewarding field to be a part of! Your unique sensibilities and approach to each situation fills your work with character and draws customers to you. The choices you make as you begin your journey will define your future and lead you down your own path.

INDEX

A

Advertising, 23, 27, 38, 99, 100–101, 110, 112, 114

Albums, 85, 86

Allebach, Mike, 51, 83, 102, 103, 109

Apprenticeship, 20

Architecture, 16–17

B

Backdrops, 42, 44, 47, 48, 114

Bills, unpaid, 68, 77

Branding, 34, 43, 45, 46, 58, 66, 86, 88, 91, 100, 102–3, 124

Bridal shows, 27, 99

Budget, 27–29, 112

Business classifications, 95–96

Business size, 30–35

C

Cancellations, 40, 72, 78

Clients, lifetime, 105–7

Commercial work, 16–17, 98

Communication, 76

Competition, 88, 98

Consultations, 76

Contracts, 72–75

Copyright, 75, 77

E

Employees, 31, 32, 34, 52–55, 56, 59

Equipment, 56–59

Equipment failure, 60–61

Expenses, 29, 53

Experience, 16–23

F

Facebook, 99, 100, 107, 112

First impressions, 71

Fickr, 85

G

Goals, achieving, 24–26

Goals, setting, 22–23

Goodemote, Dana Marie, 26, 35, 81, 86, 99, 116, 121, 123

Google+, 113

Growth, 114–17

I

Industry changes, 118–23

Instagram, 112, 113

L

Legal issues, 76–77

Lighting, 42, 45, 49, 57

Location photography, 9, 40

M

Maintenance, 23

Manthram, Mary Beth, Esq., 73, 74–75, 77

Marketing, 17, 23, 88, 102–4, 110, 114, 117

Mitova, Annie, 40, 51, 58, 91, 112–13

MySpace, 113

N

Name, business, 13

Networking, 35, 88, 97–99, 110

Niche, identifying your, 9, 11, 13, 23

Nichole, Rachel, 51, 59, 75, 83, 91, 105–7, 109, 112

P

Packages, 20, 51, 71, 75, 80, 105, 114, 116

Portfolio, 11, 17, 43, 84–87, 88

Portraits, 18, 48–49, 68, 98, 105, 114

Postproduction, 79–81, 82–83

Pricing, 14, 15, 79, 89, 123

Priore, Frank, 26, 61, 66, 67, 70, 99, 121

Priore, Joseph, 17, 20, 25, 29, 32, 38–39, 61, 64, 66, 67, 70, 71, 75, 78, 83, 99, 101, 107, 116–17, 120, 123

Products, 86

Profitability, 13, 14, 23, 29, 34

Props, 42, 47, 114

R

Real estate, 16–17, 98

Reviews, poor, 64, 71

S

Schlabach, Jefferey, 93, 94, 96

SmugMug, 85

SnapChat, 113

Social media, 99, 100, 103, 107, 108, 112

SquareSpace, 86

Studio location, selecting, 36–39

Studio sessions, 9, 114

Style, personal, 88–91

T

Taxes, 34, 92–94, 95

Travel, 48–51, 73, 74, 93

Treadwell, Aileen, 23, 46, 47, 48–49, 50–51, 59, 83, 107, 109, 110, 112, 117

Tumbler, 113

Twitter, 113

U

Urban, Neal, 26, 88–91, 101, 103, 113, 114–16, 122–23

V

Variety, 114

W

Weather, 42, 46, 57

Webshots, 85

Website, 32, 85, 86, 87, 110, 112

Weddings, 18, 31, 57, 60, 62, 67, 69–70, 75, 76, 78, 86, 116

 guest behavior, 62, 67

Wix, 86

Word-of-mouth referrals, 9,

(Word of mouth referrals, cont'd)
38, 71, 101, 108–9, 110, 114

Workflow, 79–81, 82–83

Z

Zinck, Drew, 14, 20, 26, 29, 50, 124

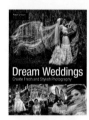